MW00564052

IMAGES
of America

TROY REVISITED

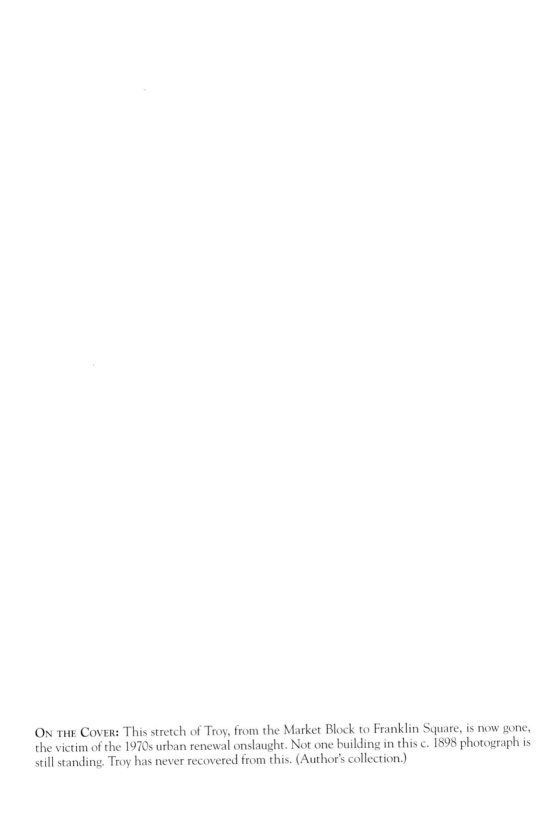

IMAGES
of America

TROY REVISITED

Don Rittner

ARCADIA
PUBLISHING

Copyright © 2013 by Don Rittner
ISBN 978-0-7385-9934-2

Published by Arcadia Publishing
Charleston, South Carolina

Printed in the United States of America

Library of Congress Control Number: 2012955496

For all general information, please contact Arcadia Publishing:
Telephone 843-853-2070
Fax 843-853-0044
E-mail sales@arcadiapublishing.com
For customer service and orders:
Toll-Free 1-888-313-2665

Visit us on the Internet at www.arcadiapublishing.com

*To Margo Bessette, Paul Klink, Jack Fitzpatrick, Dawn Marie Bauer,
Jerry Kennedy, Patricia Pellerin, and to Sandy and Frankie.*

CONTENTS

Acknowledgments

Many people and institutions have helped me over the years in my attempt to promote the city of Troy. My thanks go to Susan Holland for proofing, and to the great staff at Rensselaer County Historical Society, Kathy Sheehan and Stacy Draper. Thanks also go to Chris Hunter, from the Museum of Innovation and Science (formerly Schenectady Museum), Jim Shaughnessy, and Tom Clement. Unless otherwise noted, the images are from the author's collection.

INTRODUCTION

Many books could be written about the history of Troy, New York. This modest-sized city on the east bank of the Hudson River has that kind of past. From the days of Native American dominance, to the early Dutch and Colonial eras, to its impact on technology, Troy has made a sizable contribution to American history.

Troy Revisited focuses on the first half of the 20th century, when Troy was at its peak as an iron and textile center and when its population was at its highest level. The many foundries and forges in the south end were churning out iron rails, horseshoes, manhole covers, stoves, bells, and a host of other metal products, while collar, cuff, and shirt companies in the downtown and north central part of the city were clothing much of the nation.

Hundreds of commercial and retail stores lined downtown streets, supplying the daily needs of the 72,763 residents in 1930, the year of the city's largest population. It is now a little more than 50,000.

Troy Revisited is divided into 11 chapters that feature street scenes, interiors, landmarks, businesses, the railroad, celebrations and parades, and important institutions, such as the Boys Club. The book highlights two of city's notable institutions at the time, W.H. Frear and G.V.S. Quackenbush department stores, and reveals many of the locally owned businesses that made Troy such a commercial attraction to buyers all around the Capital District. This book also features important institutions, such as the Troy Boys Club, which helped so many boys who were not blessed with an abundance of economic resources. Finally, the book shows off the city's love for parades and celebrations, its role in wartime, and several of the city's landmarks buildings.

In essence, *Troy Revisited* is a snapshot of the city at its height of popularity. Hopefully, the various images prove to be useful and entertaining and, most importantly, lead to an appreciation of the rich history of the city.

One

THE HUDSON FULTON
CELEBRATION OF 1909

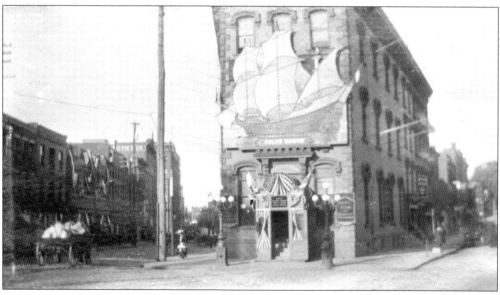

In 1909, New York State celebrated the 300th anniversary of Henry Hudson's voyage and the centennial of steam navigation with Robert Fuller's 1809 *North River Steamboat*. Most of the cities in the state, including Troy, had major celebrations during a two-week event. The festivities in Troy were the culmination. Here, the full front of the Manufacturer's National Bank is decorated with the *Half Moon*. This bank financed the construction of the Civil War–era ironclad ship USS *Monitor*. The building no longer stands. (Courtesy of Chris Hunter, archivist, Museum of Innovation and Science, Schenectady.)

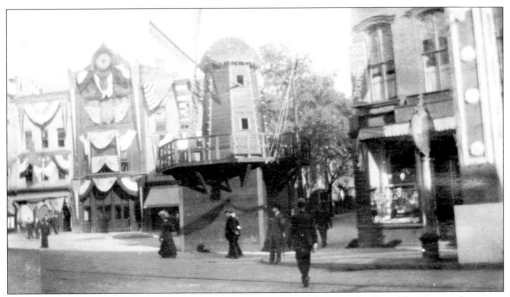

This Dutch windmill stood in front of the Boyce Studios in the popular Franklin Square between River and Fourth Streets. The entire square was torn down during urban renewal in the 1970s. (Courtesy of Chris Hunter, archivist, Museum of Innovation and Science, Schenectady.)

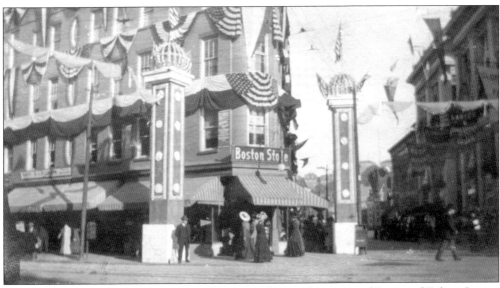

Pictured here is a celebration at the Boardman Building, at the corner of River and Fulton Streets in the Market Block. This building burned down in 1911, and its replacement was demolished during urban renewal. Frear Department Store, seen on the right, survives. (Courtesy of Chris Hunter, archivist, Museum of Innovation and Science, Schenectady.)

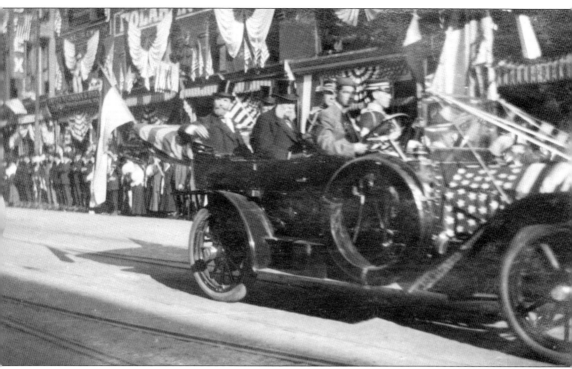

A parade car drives past Holahan & Hart Milliners at 370 River Street. This entire city block, from Franklin Square to Market Block, was later demolished. (Courtesy of Chris Hunter, archivist, Museum of Innovation and Science, Schenectady.)

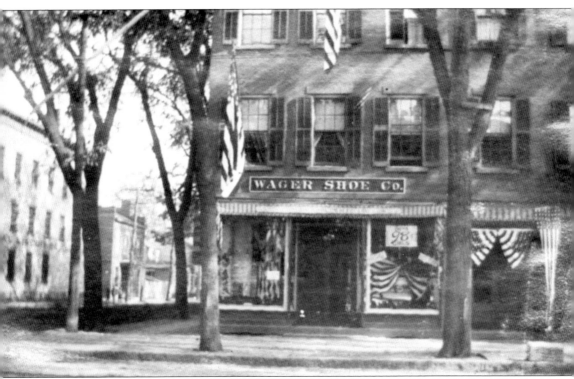

Wager Shoe Company, at 598 Second Avenue in the Burgh, participated in the Hudson Fulton Celebration. Lansingburgh, to the north of Troy, was annexed to the city only 10 years prior to the celebration. (Courtesy of Chris Hunter, archivist, Museum of Innovation and Science, Schenectady.)

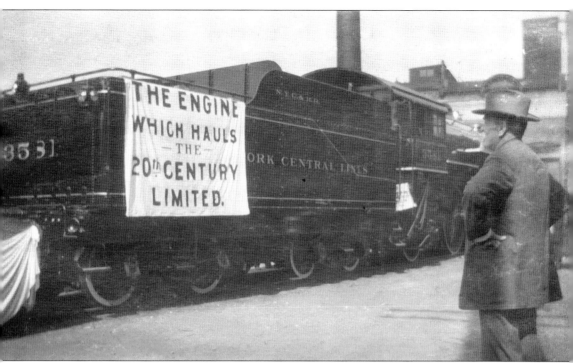

This engine, which hauled the 20th Century Limited, is seen here carrying the replica of the Mohawk & Hudson Railroad's Dewitt Clinton, New York's first passenger train. (Courtesy of Chris Hunter, archivist, Museum of Innovation and Science, Schenectady.)

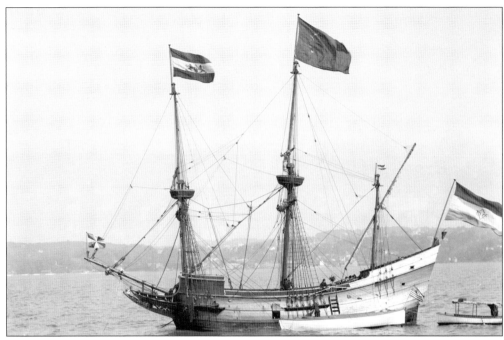

A replica of the *Half Moon* (above) participates in the Hudson Fulton Celebration of 1909. In the below photograph, the *Clermont* also takes part in the festivities. The two ships later collided. (Both, courtesy of the Library of Congress.)

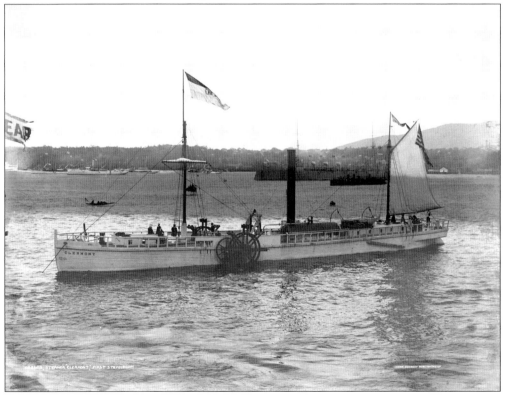

Two

THE TROY BOYS CLUB

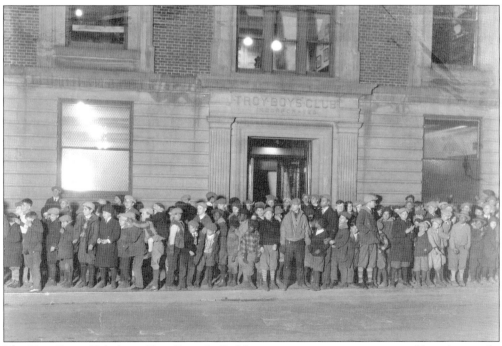

The Troy Boys Club (now Troy Boys & Girls) is an important institution in Troy that works primarily with inner-city youth. Created in 1899 by Frank G. Simmons to help poor boys, it has never strayed from its mission. Starting in the Boardman Building in 1903, the organization moved to 311 River Street, occupying the upper two floors. By 1912, the organization had its own building, shown here, at 44 State Street. The following series of photographs was taken during the time when the author was a member. On Friday nights, movies were shown—-usually of the cowboy or gladiator variety—and the boys would reenact the battle scenes after the show out on the street. This photograph was taken in 1948.

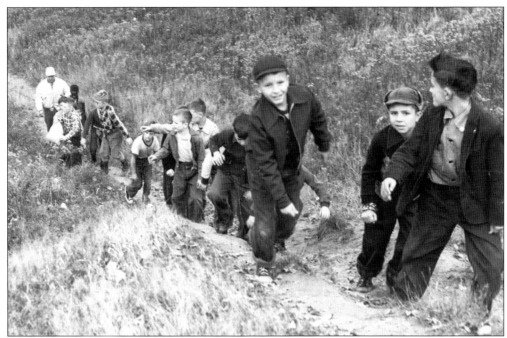

Children take the back hill path to Prospect Park to play. Rather than walk up Congress Street to the entrance of the park, local kids would take the paths that began at Seventh Avenue. A few different routes were available.

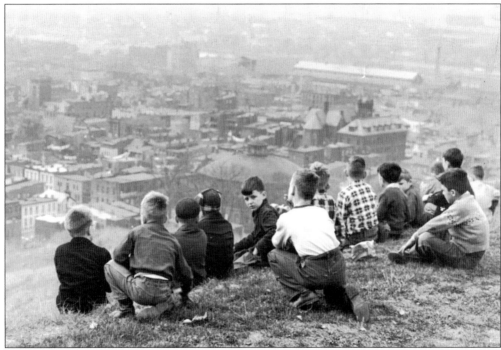

A group of boys looks over the city and each ponders his future. The round building is the gasholder house for the old Troy Gas Company, which supplied gas for lighting throughout the city during the 19th century.

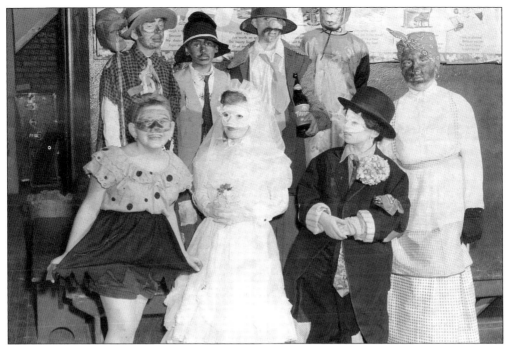

These photographs were taken during a Halloween party on October 28, 1956. The author's cousin Dave is one of the costumed characters. The Boys Club also held parties during Christmastime and other holidays to allow the children to participate and get goodies like the other kids around the city.

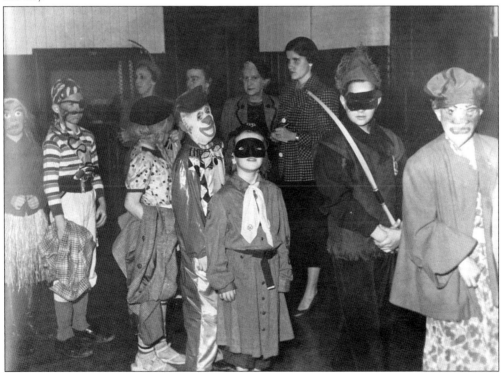

Children are having fun bobbing for apples at the Halloween party on October 28, 1956. It is questionable if current health codes would allow an agency to hold this activity anymore. In earlier times, kids would bob for apples in an actual pail of water. Perhaps this was the more "healthy" way.

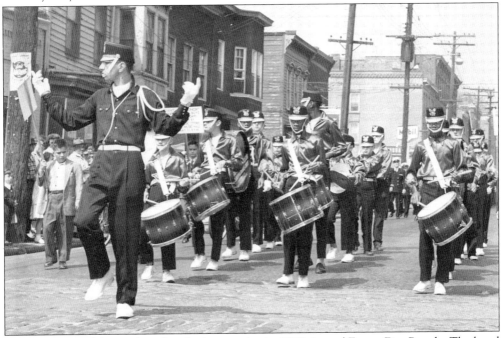

The Troy Boys Club marching band takes part in the 1958 Armed Forces Day Parade. The band is seen here on Ferry Street between Third and Fourth Streets. The buildings beyond the Mobil station are gone and have been replaced with the Ferry Street Tunnel. The building on the corner, opposite the gas station, was Bell's Tavern, known as the Rail.

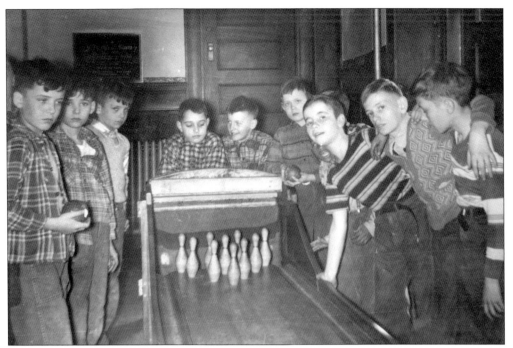

The club had many activities and games to keep kids busy. Look at the faces of some of these kids. The bowling game in the above photograph looks like it has seen better days. Members used to make leather bands and key chains, and, in an activity of unknown purpose today, boys would wrap plastic around paper plates. Below, kids are painting their plaster of paris statues.

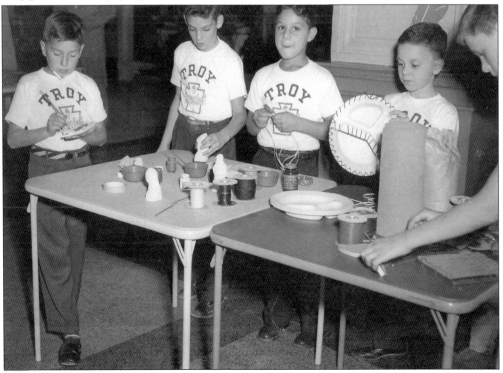

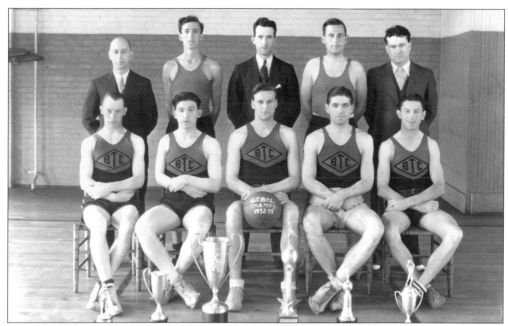

The Greater Troy Basketball League champions of 1932–1933 pose for a photograph. Recreation was an important part of life in Troy, and children would head up to Prospect Park to swim or play sports.

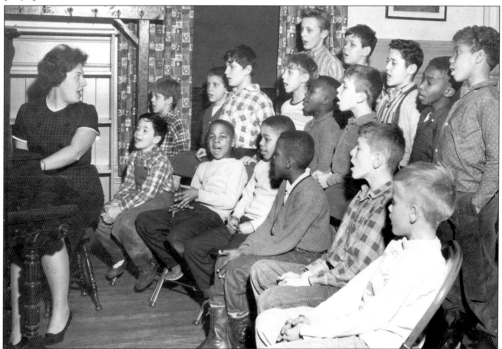

A teacher leads a singing rehearsal with Boys Club members. There was also a reading group led by a Mrs. English. The author remembers visiting her at her home on Second Street, in one of the Greek Revival houses on Cottage Row. The teachers who worked with the kids at the Boys Club were very kind, and visits to their homes were not uncommon.

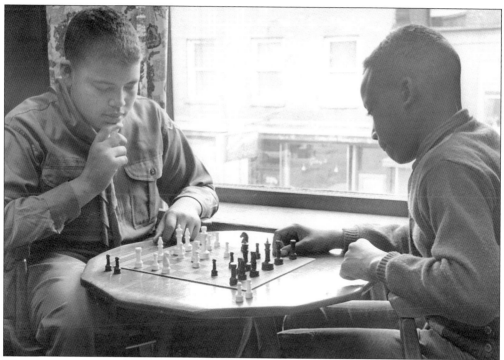

These boys are deep in thought about their next moves. A nice view of State Street below is visible. Chess, checkers, and all kinds of board games were available for the kids at the Boys Club.

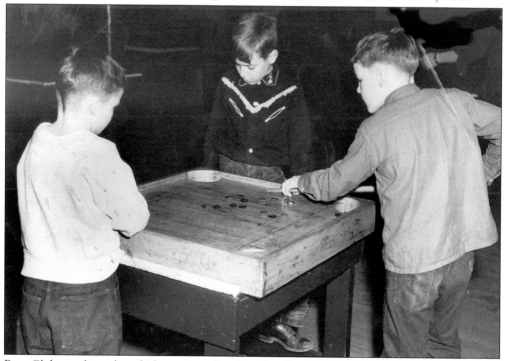

Boys Club members play a kid's version of pool on October 28, 1956. Some members later learned how to make a little money playing pool at places like Whitey's on River Street.

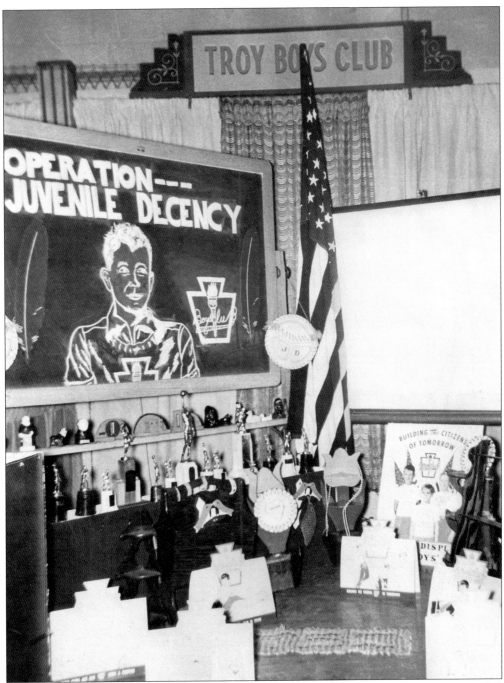

Here is the Boys Club and all of its memorabilia. Many Troy boys have fond memories of the club during the 1960s. The organization, which still thrives today, has a downtown club and one in Lansingburgh. It now helps girls as well as boys.

Three

TROY PARADES

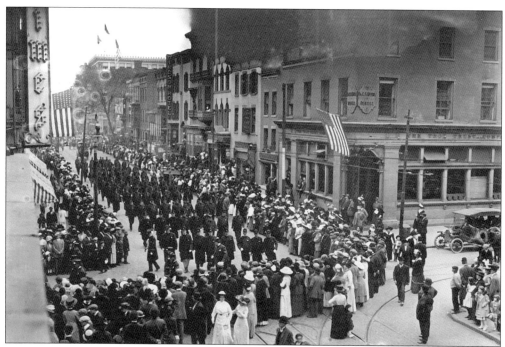

Trojans love their parades, and at one time, several different parades were held each year in the city. This chapter covers parades from World War I to the 1960s. Here, the men in blue turn the corner from Third Street onto Broadway.

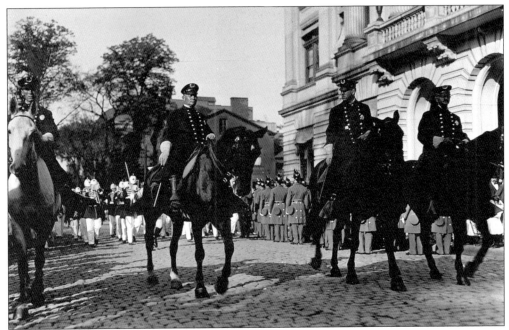

Police on horseback march past the courthouse during a city parade. Note the Belgian blocks on Second Street. Most of the city streets were covered with Belgian blocks in the 19th and 20th centuries, only to be covered later with asphalt. The change was justified on the theory that asphalt roads are easier to maintain and cause less wear on car suspension systems.

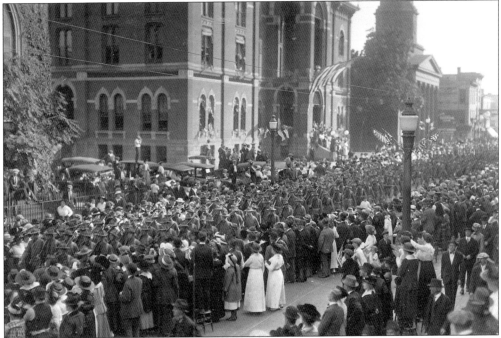

An Army unit marches past Troy City Hall on Third Street around the time of World War I. The city hall burned down in 1938, and the city government has had a real problem finding a comparable home ever since. (Courtesy of Tom Clement.)

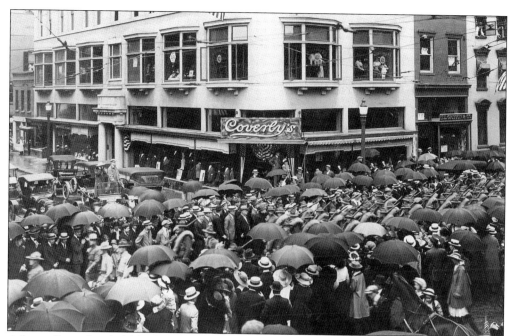

A farewell parade is held for the 106th Infantry, leaving for the Mexican border, on June 25, 1916. The unit is marching past Coverly's, which later became Wells & Coverly. The establishment, named for James M. Coverly, was located in the old Troy Times Building and was expanded after a fire. This structure became the Weed Building in 1935.

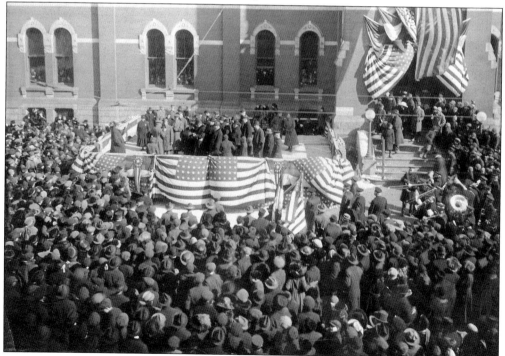

Gen. John Joseph "Black Jack" Pershing speaks at city hall during World War I. The building was designed by Troy architect Marcus Cummings.

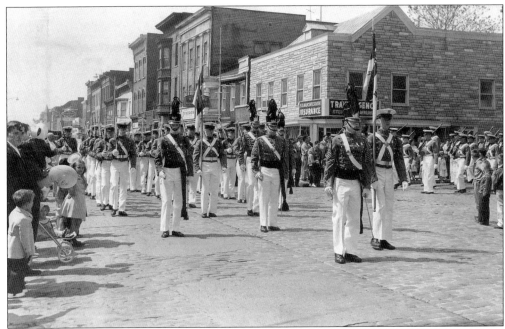

LaSalle Institute's Troy Cadets march in the Armed Forces Day parade of 1958 on Fourth and Ferry Streets. LaSalle, a well-known college preparatory school in south Troy, was founded in 1850 by the Brothers of Christian Schools, a Roman Catholic group. It moved to North Greenbush in the 1960s.

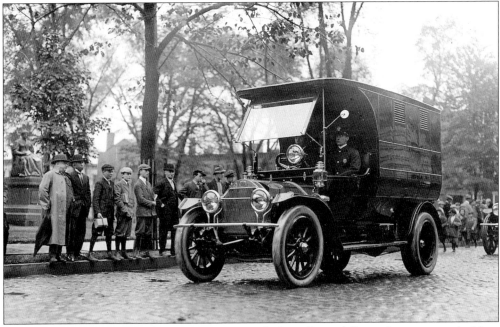

A Troy police patrol wagon drives past Seminary Park on Second Street during a parade. Note the Emma Willard statue on the left. Troy had one of the first professional police departments in the country. The term *copper*, slang for a policeman, is often attributed to Amasa Copp, one of Troy's first police chiefs.

This World War I parade drew thousands as it marched north into Franklin Square. Note the building on the left with the sign for Burleigh Lithographing Co. Lucien Burleigh was famous for his panorama drawings of major cities and towns. The only building in this photograph that still stands is the tall one, the tower, in the back. All of the buildings on this block are gone.

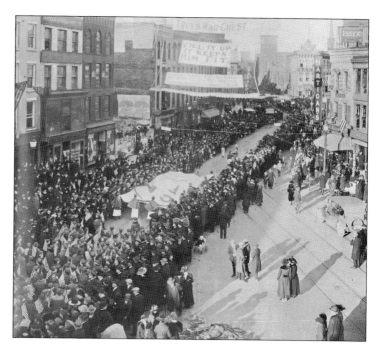

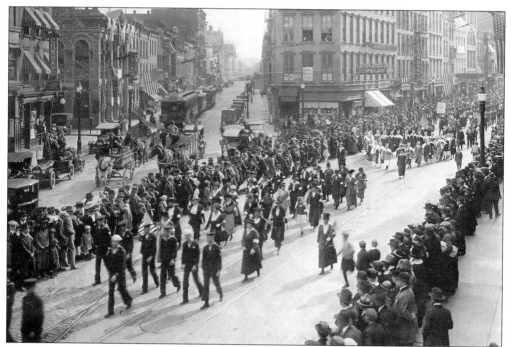

The Women's Service League marches into Franklin Square from River Street towards Chatham Square. Note the waiting trolleys. Only the buildings at the top left remain. This view is from the opposite side of that in the previous picture.

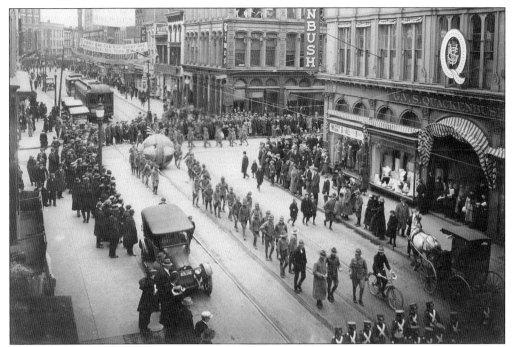

A World War I military parade marches past the Quackenbush store on Third Street. The Troy Times building (center) and all of structures up to Frear's are gone. The block is now part of what is generally considered an ill-conceived mall called the Atrium. Note the waiting trolleys.

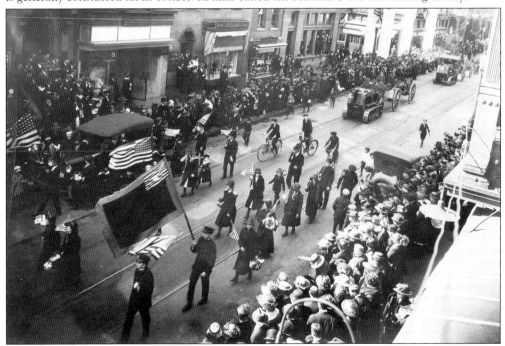

A World War I parade celebrating the troops marches south on Third Street from Broadway. This part of Third Street has escaped bulldozing for the most part, but the three structures to the left of the corner Troy Trust Building are gone. The bank was replaced as well.

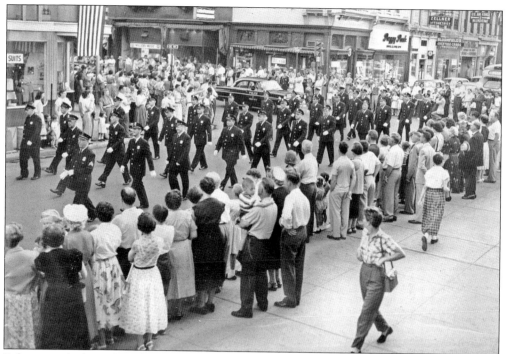

Police march down Broadway past Fourth Street in this 1960s parade, probably an Armed Forces Day parade. Fortunately, the buildings in this photograph survive. In a success story for historic preservation, the building on the immediate left, the Chazin Building, has been completely restored.

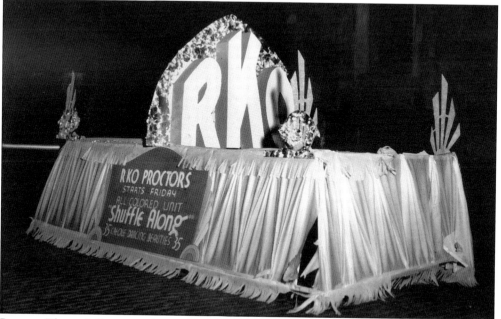

Proctors Theater's float is ready to roll with what today would be considered politically incorrect promotions. F.F. Proctors built his palace in Troy in 1914 as a vaudeville house, and it later served as a movie house. It closed in 1978, but there is a movement to restore it in 2013.

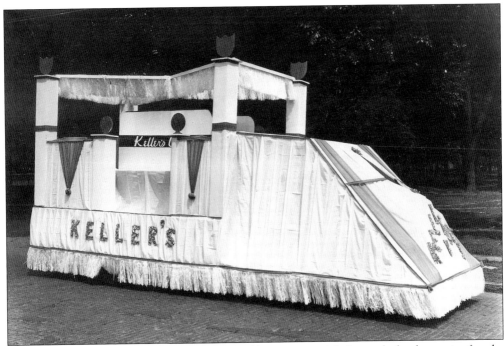

The Keller's Bakery float is ready to roll, powered by an automobile beneath the decorative facade. Famous for their Never-Krum Bread, the Keller family, Julius and Gustav, were rivals of the Freihofer Bakery. Both companies were situated in the Burgh, and both were great bakeries.

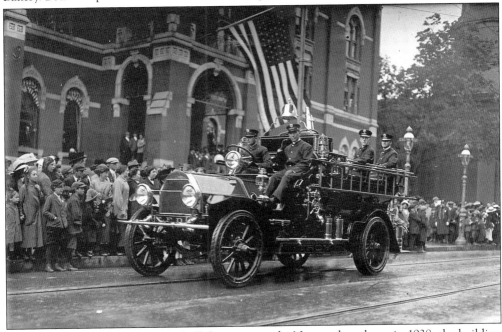

A Troy fire truck cruises past city hall during a parade. Not too long later, in 1938, the building burned to the ground under suspicious conditions. Rumor has it that the blaze was started by supporters of the party that lost the election that year. It is now the site of Barker Park. (Courtesy of Tom Clement.)

Four

TROY LANDMARKS

The city of Troy has many architectural landmarks. This chapter will highlight a few such treasures of the present and past. The First Baptist Church on Third Street, built in the early 19th century, is seen here. It still tends to its congregation each week. Troy City Hall can be seen at the far left. It burned down, and the site is now occupied by Barker Park.

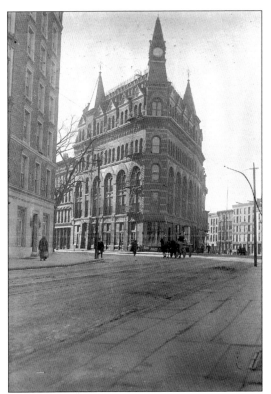

Seen at left, on River Street where it intersects with First Street, is the Rensselaer Inn, built in 1905. The name was changed to Hotel Troy in 1924. At center is the Rice Building. The reason for that building's name is not known. Benjamin Hall erected it as the Hall Building in 1871.

The Telephone Building (center) and Proctors Theater line the east side of Fourth Street from State Street. The streets seen here were not paved at the time of this photograph. Some city streets were not covered at all, having only dirt on their surfaces, as with this section of Fourth and State Streets. Some had cobblestones, some bricks, and some were built of Belgian blocks. The Telephone Building has since been remodeled with the addition of a modern marble facade that some feel destroyed the original grandiose look of the building.

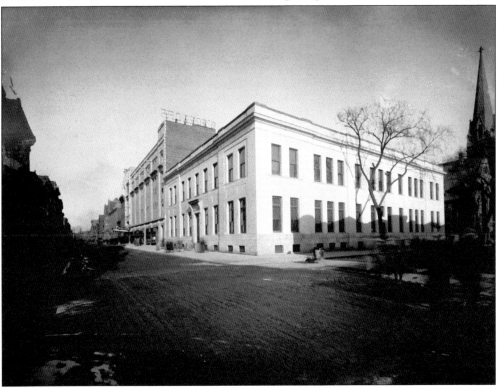

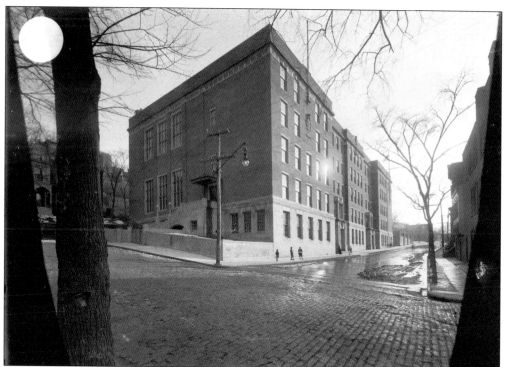

This building was School No. 5 Elementary in the 1960s, but was built as the Central School in 1913. It later became the high school, and is now the Rensselaer County office building. The houses visible on the right and in the rear are now gone. Nothing but the school building remains.

The Thomas Samuel Vail House, at 46 Second Street, is seen here in 1946. It was built in 1818 and now serves as the residence of the president of Russell Sage College. (Courtesy of the Library of Congress.)

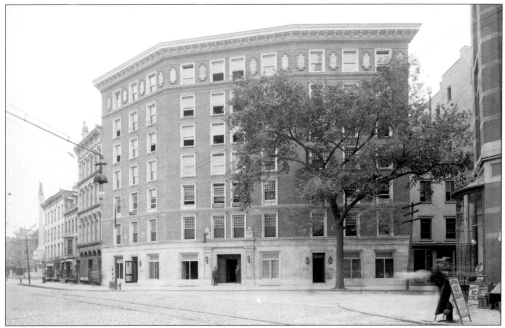

Rensselaer Inn, also known as Rensselaer Hotel, was built in 1905. The name was changed to Hotel Troy in 1924. The building that preceded this was the Troy House. The Troy & Schenectady Railroad cars would turn around here in the 19th century. The buildings on the left in this 1905 photograph are gone. (Courtesy of the Library of Congress.)

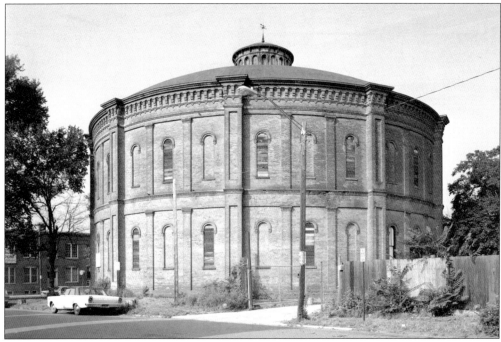

The gasholder house for the Troy Gas Light Company, at Jefferson Street and Fifth Avenue, was built in 1873 to supply homes and business with gas. It is now depicted as the logo for the Society for Industrial Archeology. (Courtesy of the Library of Congress.)

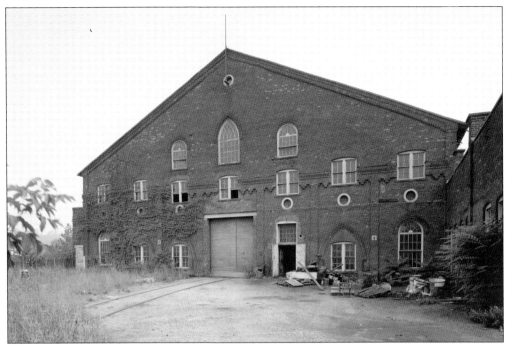

The Rensselaer Iron Works Rail Mill was built in 1846 at Adams Street and the Hudson River. Rivets and bolts for the USS *Monitor* were produced here. In 1896, the buildings became part of Ludlow Valve. The author witnessed the complex burn down in October 1969. (Courtesy of the Library of Congress.)

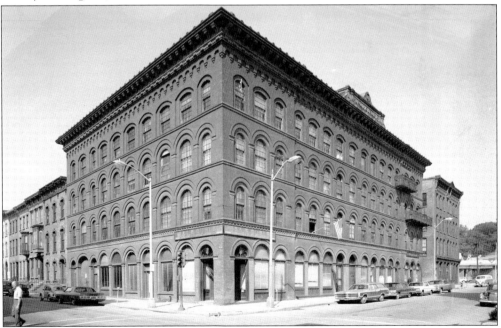

The W. & L.E. Gurley Building, at 514 Fulton Street, was built in 1862. Surveyors' tools were produced in this building. The annex was torn down for parking. This structure now houses the RPI Lighting Institute. (Courtesy of the Library of Congress.)

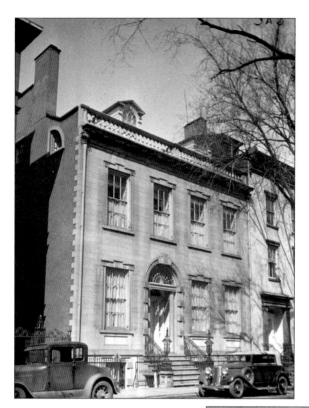

Albert Cluett House purchased this home at 59 Second Street in 1910. It was built in 1827 by William Howard and is now the home of the Rensselaer County Historical Society. (Courtesy of the Library of Congress.)

Seen here is the front entrance of the Central School in 1913. The school later became Troy High School and is now the Rensselaer County offices. The author's only stage performance, as a rabbit in *Peter Pan*, took place at this school when he was in the fourth grade. The principal here was known to use a rubber hose if a student got called to his office.

Troy City Hall, at the corner of State and Third Streets, is seen here in 1905. Built in 1876, it was designed by well-known Troy architect Marcus Cummings. The edifice burned down in 1938, and the location became the home of Barker Park.

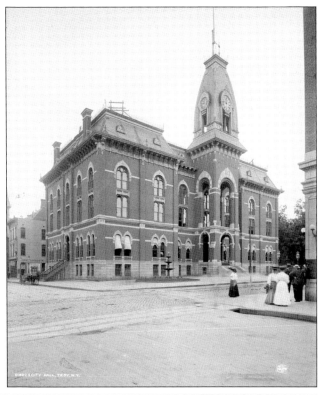

The Rensselaer County Courthouse, built in 1894, is the third courthouse on the site. It was designed by Marcus Cummings. The church to the south of this building was purchased and turned into the court annex. This photograph was taken in 1905.

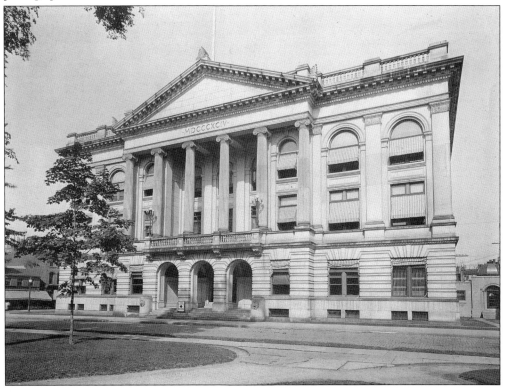

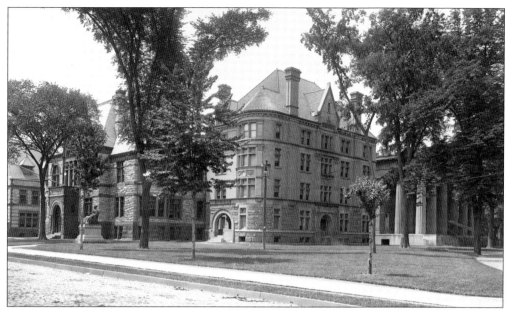

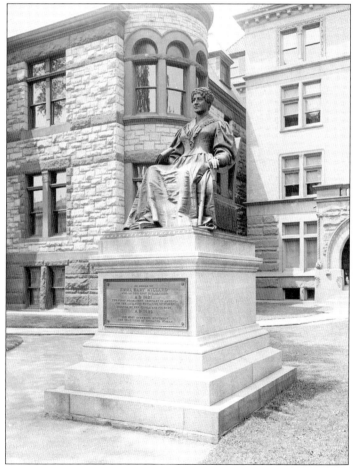

Russell Sage College, formerly the Emma Willard School, was created in 1916 as a women's school. It is seen here in 1900. (Courtesy of the Library of Congress.)

Pictured here in 1905 is the Emma Willard statute on the campus of what is now Russell Sage College. Willard started the Troy Female Seminary in 1821 as one of the first schools to educate women only. It was renamed Emma Willard School in 1895. The statue was dedicated on May 16, 1895. (Courtesy of the Library of Congress.)

This is another view of Troy High School, formerly Central School, on Seventh Avenue. The building at the end is the Troy Academy, built in 1863. It later became Rensselaer Polytechnic Institute. The homes visible at right, on Eighth Street, are now gone.

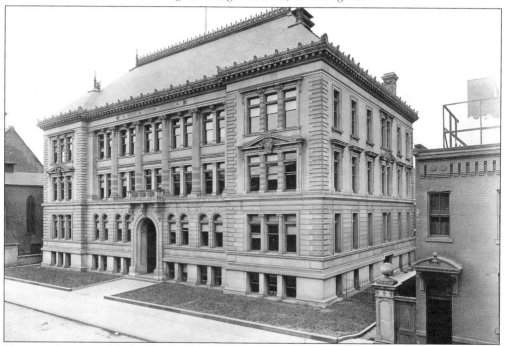

The site of Troy High School, on Fifth Avenue, is now a parking garage. The school, shown here, was built in 1898 and demolished in 1963 after the city refused to fix a leak and damaged the building as it was being considered as a possible city hall.

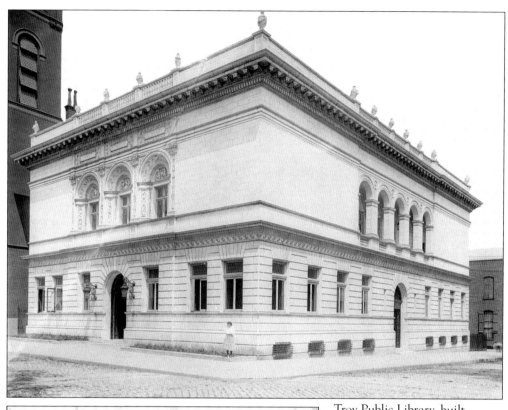

Troy Public Library, built in 1897, included a Tiffany window. It is one of the most beautiful buildings in the city and continues to serve as a library for all Trojans. (Courtesy of the Library of Congress.)

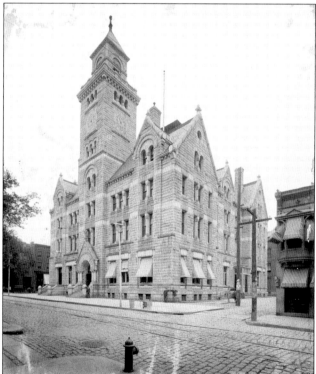

The original Troy Post Office, seen here, was built in 1894. It was replaced by the current edifice, built by the Works Progress Administration (WPA) in 1936. The small men's hotel on the right is now Finnibar's Irish Pub. Visible on the other side of the post office are homes along Fourth Street.

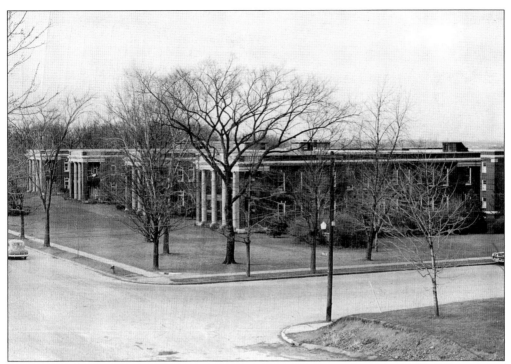

Troy's Samaritan Hospital began in the halls of Troy Orphan Asylum on Eighth Street in 1898, eventually moving to this campus on the corner of Burdett and Peoples Avenues in the early part of the 20th century. The above photograph was taken on November 20, 1948. The campus looks quite different today, but the three main buildings are still standing.

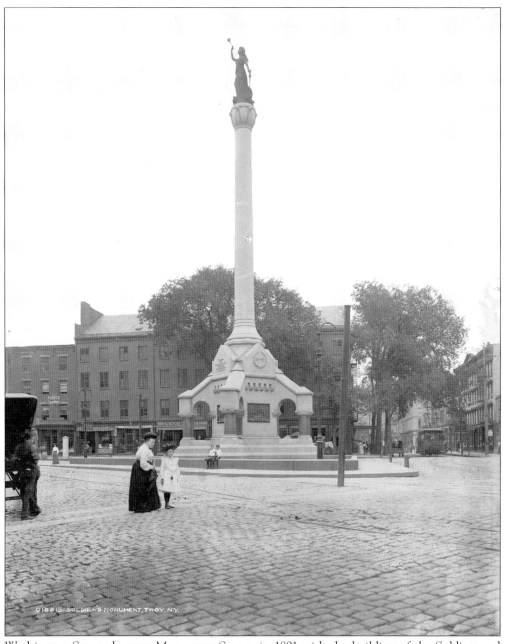

Washington Square became Monument Square in 1891 with the building of the Soldiers and Sailors Monument. In the background of this 1905 photograph is the Mansion House, which was replaced by the Hendrick Hudson Hotel in 1925. (Courtesy of the Library of Congress.)

Five

MILITARY

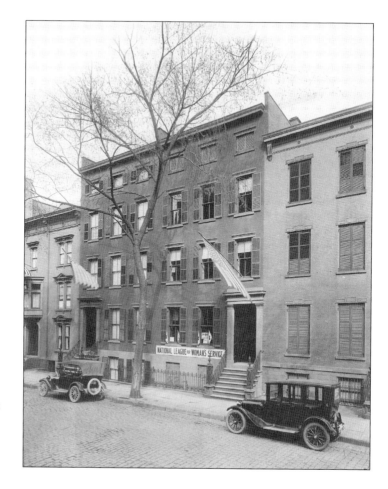

The Second Street headquarters of the National League for Women's Services is seen here during World War I. The organization was established to coordinate and direct the activities of women across the country.

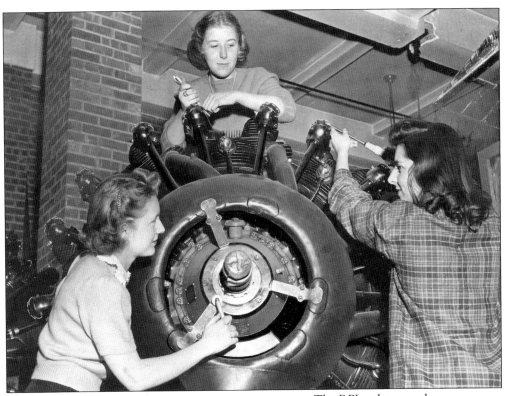

The RPI cadets seen here on February 25, 1943, are Beryl Jeffries from Maplewood, New York (left), Carolyn Landon of Rutland, Vermont (center), and Beth Smiley from Ithaca, New York.

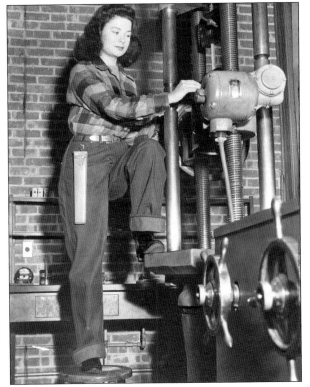

Rosemary Hubbard Noeleans was a member of the Curtiss-Wright Cadettes. Here, she adjusts a tensile strength tester on the same day as the activity pictured above. While not allowed to fight in the war, young women in college and out of college did their part. In 1942, RPI admitted a limited number of women to be trained as scientists and technologists.

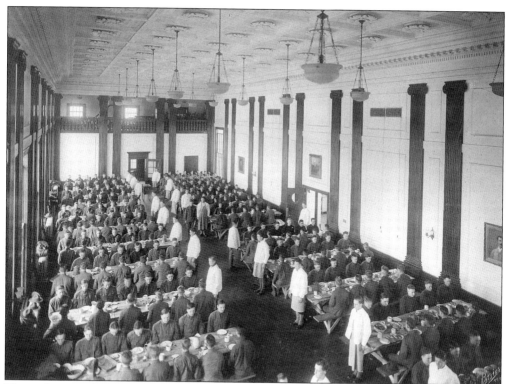

These photographs show the Mess Hall on the RPI campus during World War II. In the war, RPI was one of 131 colleges that took part in the V-12 College Training Program, which prepared young men for a path to a Navy commission.

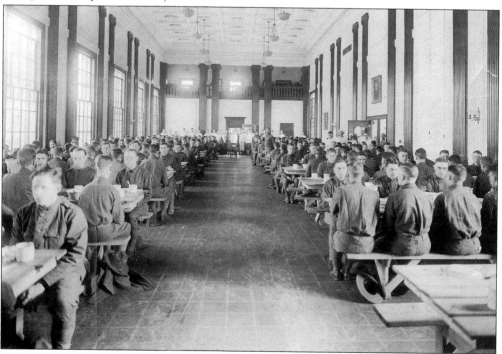

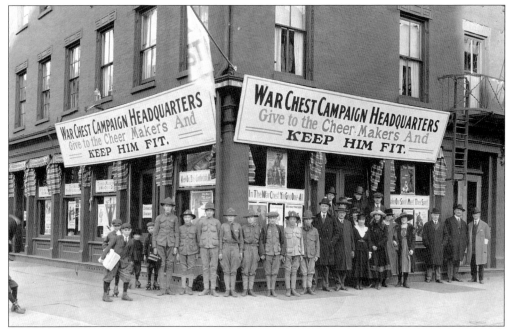

The War Chest Campaign Headquarters was located in the Mansion House, at the corner of Second Street and Broadway, during World War I. Mansion House was a popular Troy hotel for many years until it was replaced with the Hendrick Hudson Hotel, which still occupies the site today. The Mansion House had a beautiful cast-iron storefront.

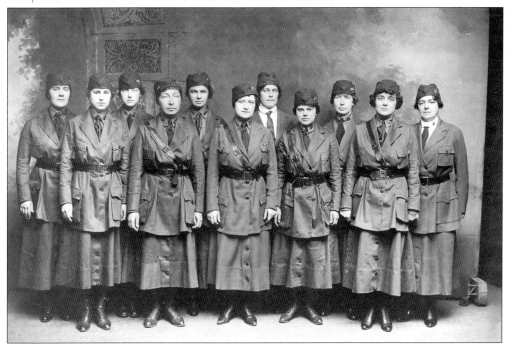

Seen here are members of the Troy Motor Club National League for Woman's Service. The organization was established to coordinate and direct the activities of women across the country. It was headquartered on Second Street.

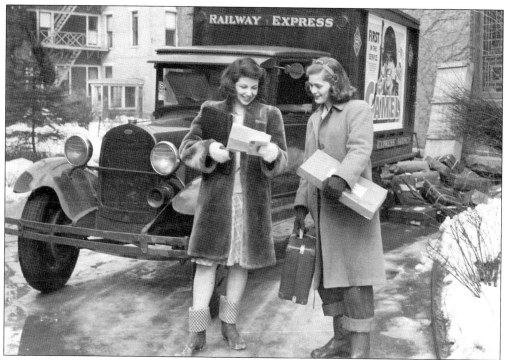

Reading her mail from service members using the Railway Express Agency (REA), predecessor of UPS and FedEx. The author's father was the platform manager at the train station for REA.

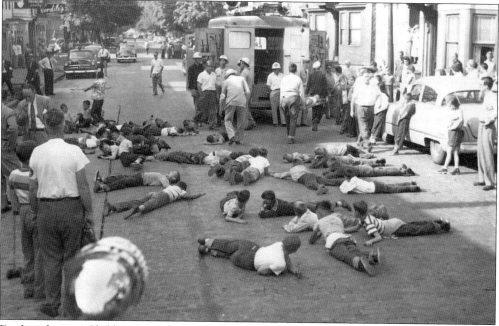

Duck and cover! Children from the Lansingburgh Boys Club act as "bodies" during a civil defense drill conducted between 115th and 116th Streets along Second Avenue. The author remembers these drills as a boy in elementary school. Children were trained to hide under their desks in the event of a nuclear explosion. It was never made clear how such evasive action would save lives.

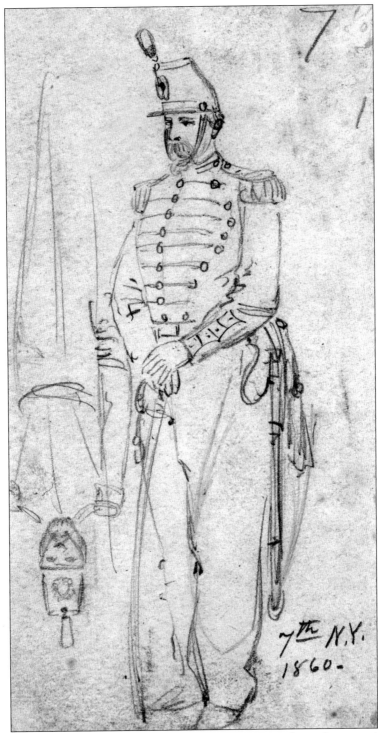

This sketch of the 7th New York Cavalry Regiment uniform was drawn by artist Allred Rudolf Waud (1828–1891) in 1860. This regiment was organized in Troy in November 1861. (Courtesy of the Library of Congress.)

Six

UNION DEPOT AND THE RAILROAD

Troy Union Station is seen here in 1901. This station was the centerpiece for transportation until the 1950s. Trains came into the city from the south, north, and west, and had the right-of-way over all other traffic. The author's father was the platform manager for the Railway Express Agency, the company that conveyed mail from the trains to the post office and back.

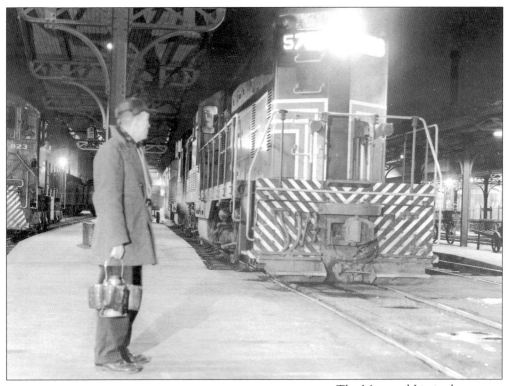

The Montreal Limited prepares to leave Troy for New York City on track No. 3 in March 1955. The author met his father at the station almost every day, helping him deliver the mailbags to the train post cars or taking the mail to the post office. (Courtesy of Jim Shaughnessy.)

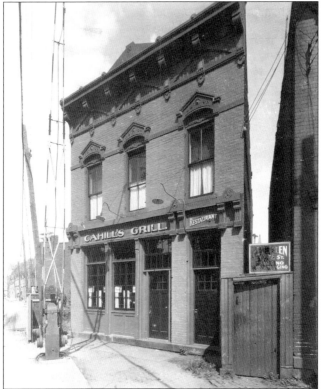

Cahill's Grill was located right off the tracks at 268 Second Street. The building is now a house, and the tracks are gone. Many buildings in Troy were built at weird angles along the train right-of-way. By locating such buildings, one can determine the long-gone paths the old tracks took.

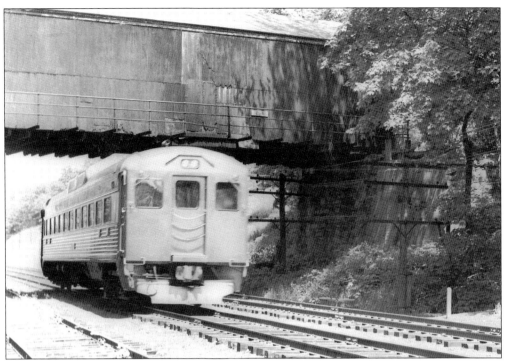

A Boston & Maine Railroad Budd Rail Diesel Car passes under the Oakwood Cemetery Covered Bridge on its route from 101st Street to the Troy station after a run from Boston in June 1951. The bridge was later burned down by vandals. (Courtesy of Jim Shaughnessy.)

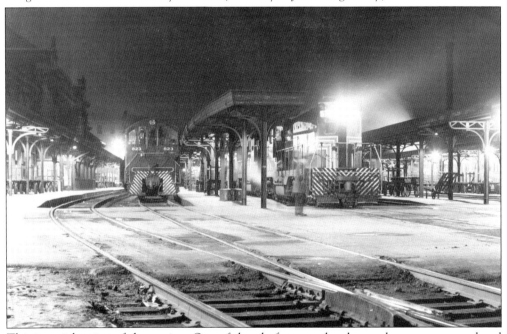

This is a night view of the station. One of the platform overheads seen here was removed and taken to a popular kids' playland in nearby Latham, New York, to be used as a place from which to hit golf balls. It is still used in that capacity today. (Courtesy of Jim Shaughnessy.)

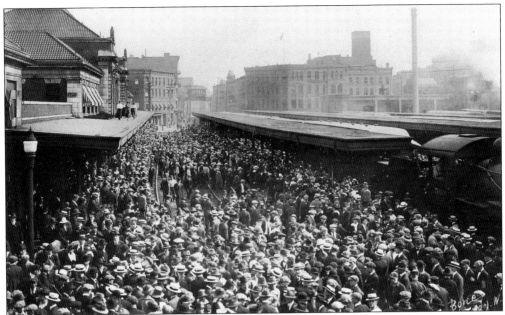

In this crowd scene at the station, it seems that someone of prominence is coming to visit. Often, presidential candidates would make whistle-stops at cities and give talks from the back of a railcar. Since there appear to be no soldiers in the photograph, it is likely a political stop in Troy. The Tolhurst 7 Sons Machine Works in the background made machinery for the collar and cuff trade.

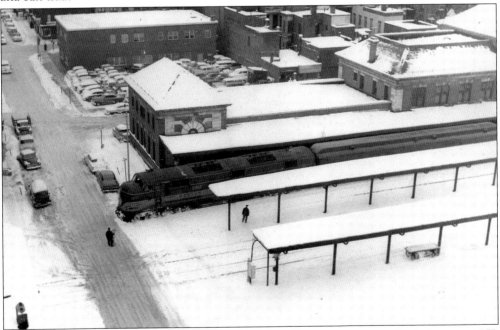

Train No. 51 arrives in Troy with engine No. 3812 from Boston on a snowy day in January 1957. The row of brownstones above the train station was torn down, beginning the historic preservation movement in the area during the 1970s. The brownstones on the west side are still standing. (Courtesy of Jim Shaughnessy.)

An engineer is getting ready to hook on some cars in this north-facing view. The houses visible at center stood along Grand Street and have since been razed. (Courtesy of Jim Shaughnessy.)

A Boston & Maine engine zips through the Middleburgh Street area. The repair yards for the B&M were located just to the right of this photograph. These tracks and most of the buildings seen here are gone. All that survives is the roundhouse, which is being used by a boiler company. (Courtesy of Jim Shaughnessy.)

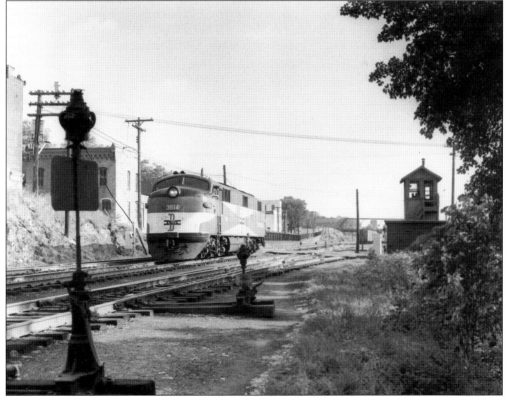

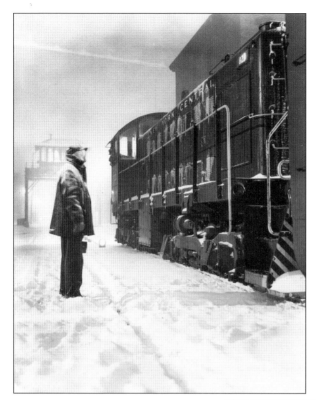

A railroad employee checks an engine as it connects to a car. Unlike with modern roads, the effects of snow rarely stopped the trains from running. Trains often had a snow car at the front, fitted with a scooper to remove snow. (Courtesy of Jim Shaughnessy.)

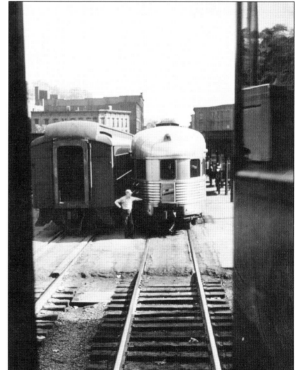

All aboard! Often, the train cars would extend into Broadway, seen here in the foreground. Pedestrians would have to climb into the cars and exit on the other side to cross the street. (Courtesy of Jim Shaughnessy.)

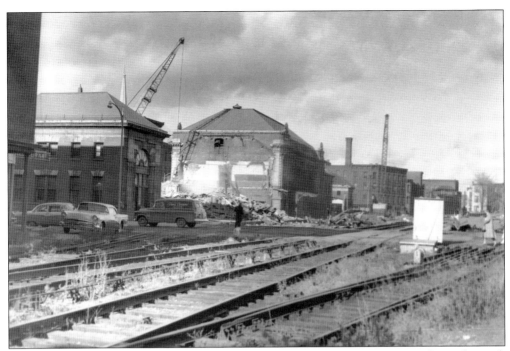

With the increase in automobile use and highway construction, passenger rail was doomed. Troy's iconic station was torn down in the early 1950s and, ironically, replaced with a parking lot. (Courtesy of Jim Shaughnessy.)

Here, a mighty steam engine is on its way into the Congress Street tunnel. The police station is on the left as the engine rolls over State Street. Remarkably, many residences were located along Sixth Avenue, adjacent to the tracks. The author has seen pictures of people with their windows open as these steam engines chugged by, probably filling the apartments with soot. (Courtesy of Jim Shaughnessy.)

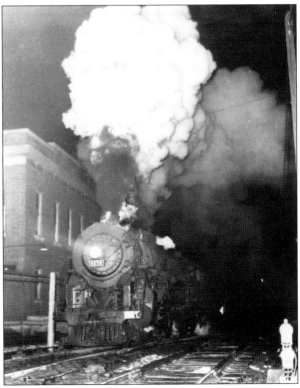

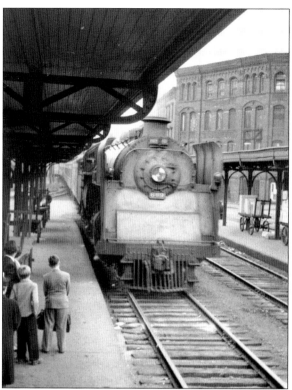

A Delaware & Hudson Railroad (D&H) train arriving from Montreal pulls into Troy Union Station in July 1949. The Lincoln Hotel is on the right. The train is crossing Broadway. It appears that this train extends all the way back to State Street, near the police station and just out of the train tunnel. (Courtesy of Jim Shaughnessy.)

Boston & Maine passenger train No. 62 waits to depart the Troy Union Station for a trip to Boston on track No. 5 at Fulton Street Crossing. This photograph was taken on January 17, 1958. (Courtesy of Jim Shaughnessy.)

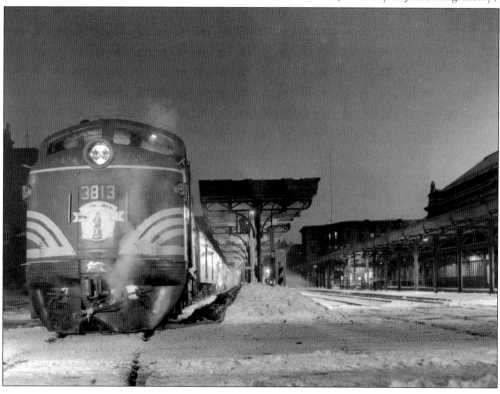

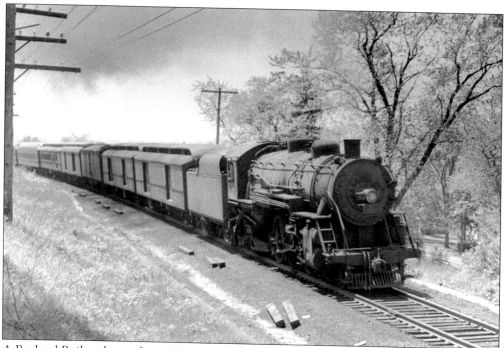

A Rutland Railroad train leaves Troy, by Cemetery Lane in front of the old Boradaile mansion in Lansingburgh. This train made a daily trip to Montreal via the western Vermont route. This photograph was taken in July 1949. (Courtesy of Jim Shaughnessy.)

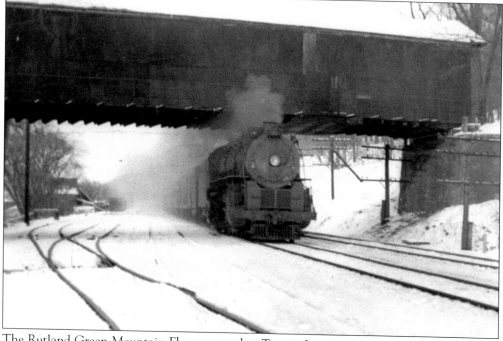

The Rutland Green Mountain Flyer approaches Troy in January 1949. It is passing under the cemetery covered bridge that led from 101st Street to the Oakwood Cemetery. The train is on its daily trip from Montreal via the western Vermont route. (Courtesy of Jim Shaughnessy.)

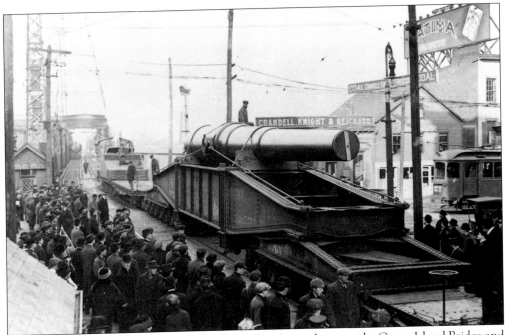

A train carrying a huge cannon from the Watervliet Arsenal crosses the Green Island Bridge and over River Street on the way to the train station. The Troy & Schenectady Railroad was one of only two municipally owned railroads in the country. The earlier wooden bridge caught fire in 1862 and burned most of downtown to the ground.

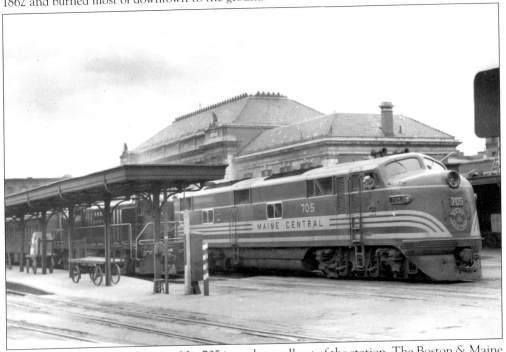

Boston & Maine Railroad engine No. 705 is ready to roll out of the station. The Boston & Maine Railroad had repair yards off Middleburgh Street in the city's north-central section. All that remains is a single roundhouse devoid of the turntable and rails. (Courtesy of Jim Shaughnessy.)

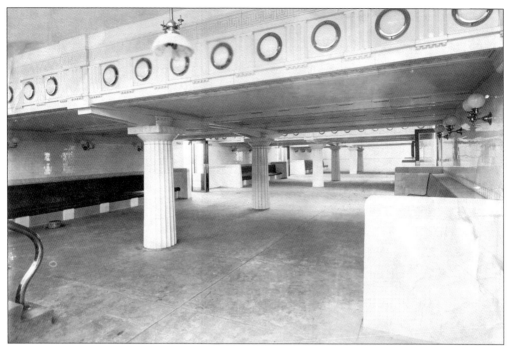

The subway went under the tracks east of the station, offering passenger access to take trains heading north to Massachusetts. Built with classical design elements, it allowed passengers to walk under almost a dozen tracks above so that they could board the trains running north and west into Boston. Remains of it may exist under what is now Sixth Avenue.

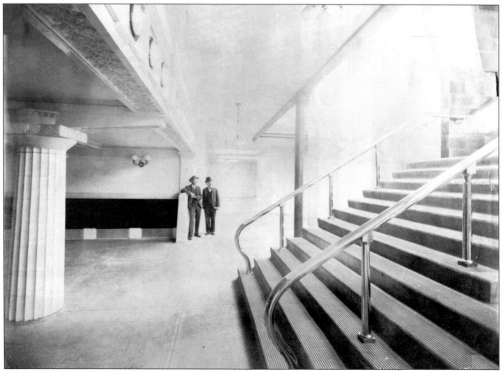

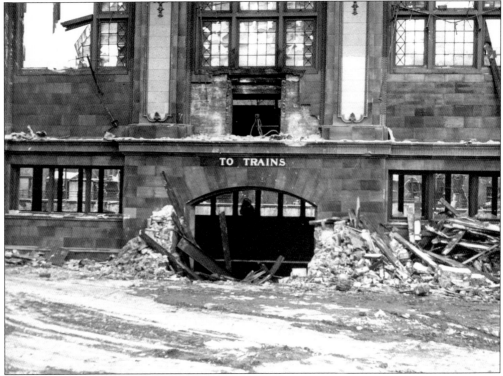

Shown here is the entrance to the subway. Unfortunately, the station was torn down and replaced with a parking lot. Above the sign to the trains was a large clock, which was recently sold at an auction. Demolition of the station is considered by many to have been a shortsighted act. (Courtesy of Jim Shaughnessy.)

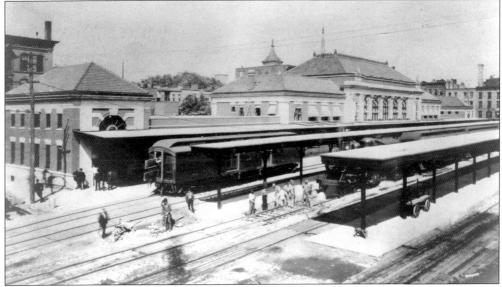

This view is looking northwest from Broadway around 1903 at the platform area at the south end of the station. It appears that workmen are placing Belgian blocks along Broadway. All of the buildings in this photograph have been razed. (Courtesy of Jim Shaughnessy.)

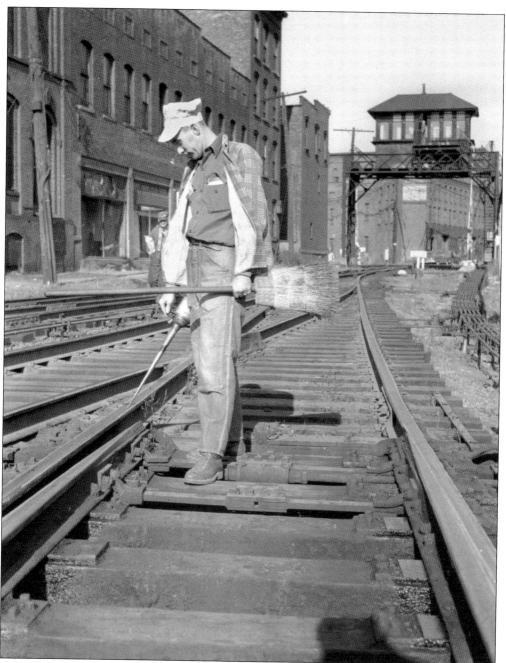

A worker greases a joint near Fulton Street. Just past the tower is Grand Street. Beyond the control switching tower are the tracks that went to the west via Federal Street, over the Green Island Bridge, and straight to the right down through Lansingburgh. This is now Sixth Avenue. (Courtesy of Jim Shaughnessy.)

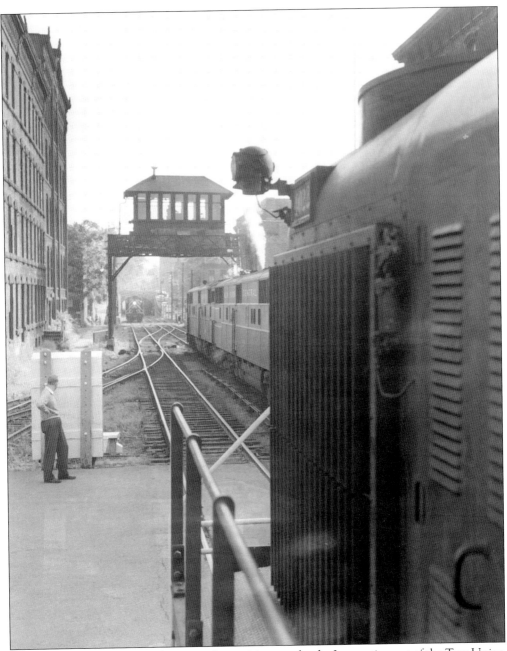

A view from one locomotive shows another waiting to take the Laurentian out of the Troy Union Station to New York City. The control tower in the distance, Tower No. 1, was between Broadway and State Street at what is now Sixth Avenue. (Courtesy of Jim Shaughnessy.)

Seven

G.V.S. Quackenbush & Co. Department Store

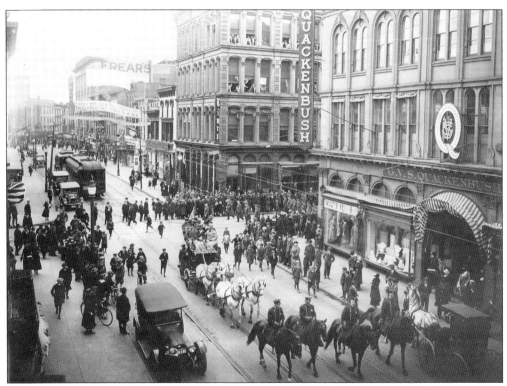

One of Troy's earliest department stores was opened in 1824 at 202 River Street under the name G.V.S. Quackenbush & Co. It moved to this location at the corner of Broadway and Third Street in 1856. Gerrit Van Schaick Quackenbush opened the city's earliest dry goods store. It became a shopping mecca for many years, into the 20th century. The images of window displays on the following pages were taken in the 1930s. The doors closed for good on August 3, 1937, and W.T. Grants moved in, occupying the site until the 1970s, when urban renewal forced it out. The company went out of business in 1975, unable to compete with the suburban malls.

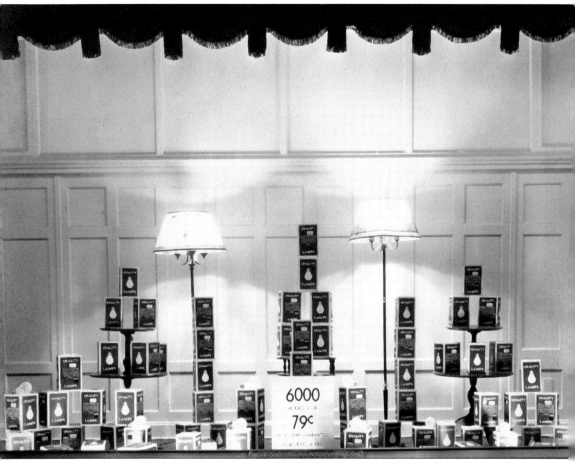

Below-quality lightbulbs, selling for 79¢, are displayed in a window. Electric lights were still pretty novel in the 1930s and were made by a number of companies. There seems to be no brand name on these. While one would expect to see GE bulbs, since its headquarters was in nearby Schenectady, these bulbs could have been made by Westinghouse or another company.

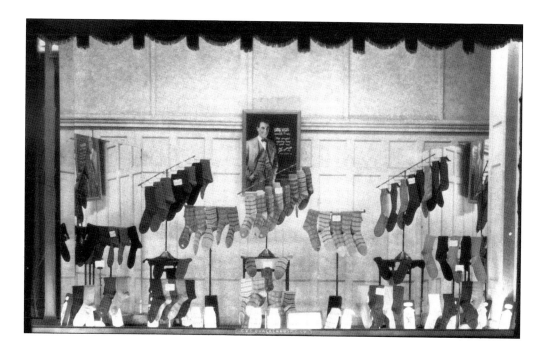

Extra Wear Hosiery (above) was trademarked on September 17, 1926, by William M. Wilbur in New York. Bear Brand Hosiery (below) was created in 1922 from the old Paramount Knitting Company of Kankakee, Illinois. "The Extra Wear brand must be good, says Johnny Hines" was an ad campaign for the brand. Hines was a comedic actor (*The Cub*, *Conductor 1492*) during the 1920s until 1940. From 1925 to 1928, he was a member of First National, which was a group of theater owners who eventually created their own movie studio in 1924.

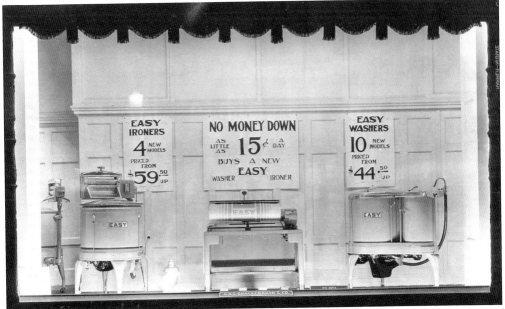

The Syracuse Washer Corporation was organized in 1917. It grew out of a company founded by two Vermont natives, G.A. Dodge and Walter Zuill, who made washing devices as early as 1877. John N. Derschug, a salesman and advertising executive, invested in the company, joining the firm in 1915 and changing the name to Syracuse Washer Corporation in 1917. The company name was changed to Easy in 1932.

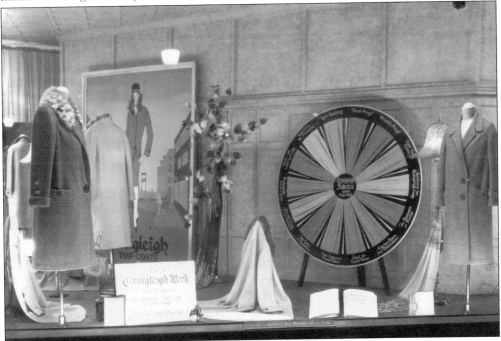

Craigleigh brand coats were trademarked by Piper & Salerno Co. Inc. on August 31, 1923. The fur-lined collars, politically incorrect today, kept one's neck warm in the winter. These products were made from 100-percent wool.

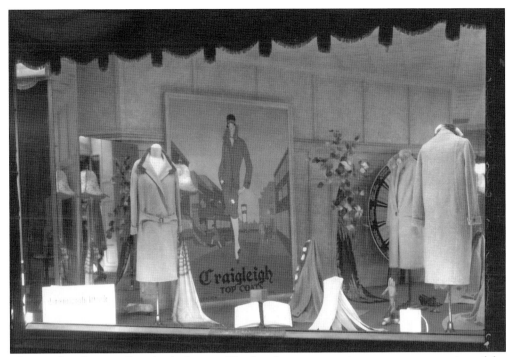

This window features Craigleigh designs. The London art poster is a great representation of the era. The store is advertising Craigleigh Week, so good deals were probably to be had.

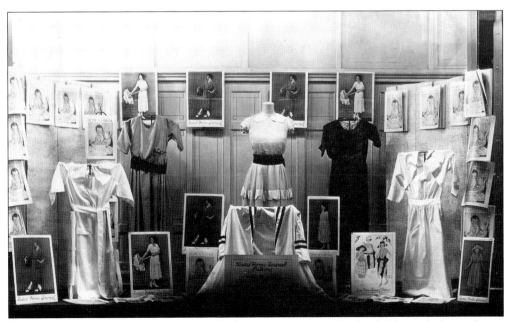

New *Ladies' Home Journal* patterns for the homemaker are on display. Making clothes at home was still a popular pastime, and in many cases a necessity. Women looked forward to reading about new styles from the *Journal* every month.

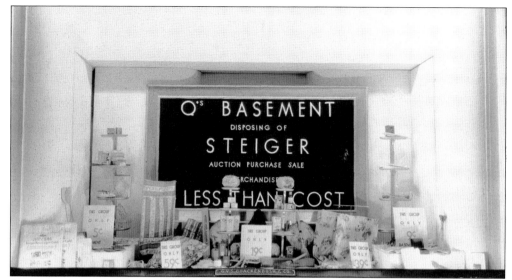

Steiger's, a department store in Springfield, Massachusetts, began in 1891. It was acquired by the May Company in the 1990s. Here, it appears that Quackenbush may have been selling off some items from a recently closed Steiger's store.

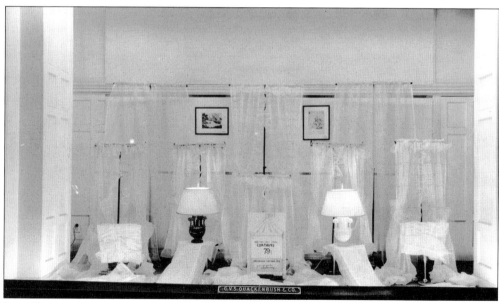

Priscilla cottage curtains are shown on sale. This series of Quackenbush Department Store window displays provides an accurate reflection of home and style during the 1930s in Troy.

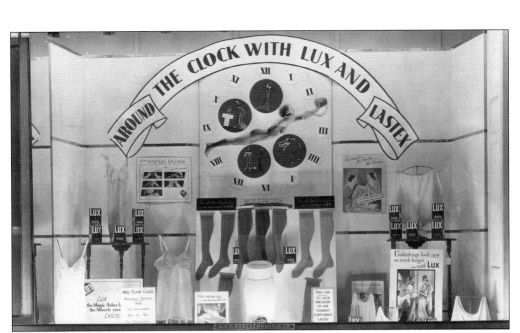

Lux was a soap invented by Lever Brothers in 1899. Originally Sunlight Flakes, the name was shortened to Lux in 1900. Lux means "light" and hints at "luxury." The toilet soap was launched in 1925 and was promoted by hundreds of stars. Lastex was an elastic yarn that gave clothes the ability to stretch. It was developed by James, Percy, and Seth Adamson in 1932. DuPont obtained the rights to the product in the early 1930s while the brothers were suing each other.

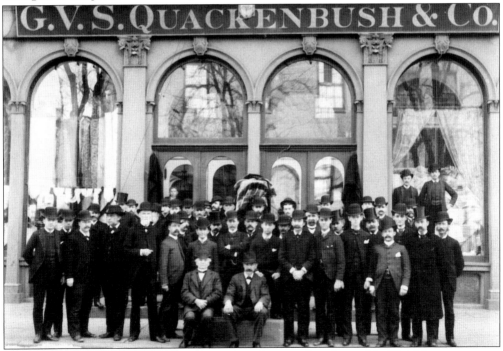

Ready to serve, Quackenbush employees pose for a photograph in front of the Third Street entrance. This photograph was probably taken during one of the anniversaries of the store, which opened here in 1856. It would serve the public until it closed in 1937.

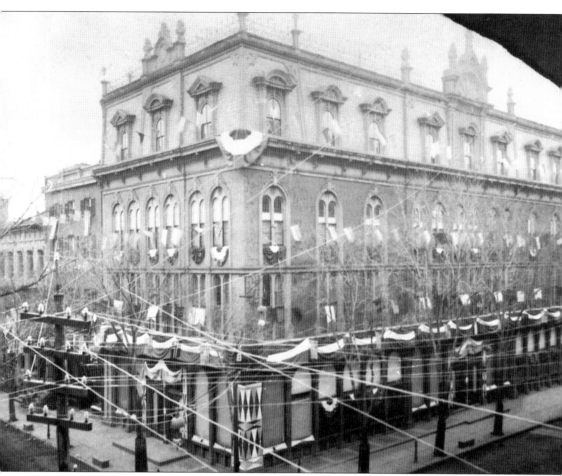

The Quackenbush store is seen here amid a tangle of electric lines. During its heyday, the building expanded to the east along Broadway, replacing residences and creating the area that housed the large display windows shown in this chapter. During the 1960s, the building housed W.T. Grants Department Store. It awaits rediscovery by some innovative company to transform it into a new life.

Eight

W.H. FREAR DEPARTMENT STORE

William H. Frear was
known as the man
who invented the
phrase "Guaranteed
or your money
cheerfully refunded."
Frear's Department
Store was one of
the most popular
in the city until the
1970s, when the
urban renewal period
began. This building
would have been
torn down if the city
had not run out of
money. The Frear's
Annex on Fulton
Street did suffer that
fate, however. Today,
Frear's is office space.
The first floor, with
its famous so-called
Gone with the Wind
staircase, is gone.
The beautiful atrium
inside was left intact.

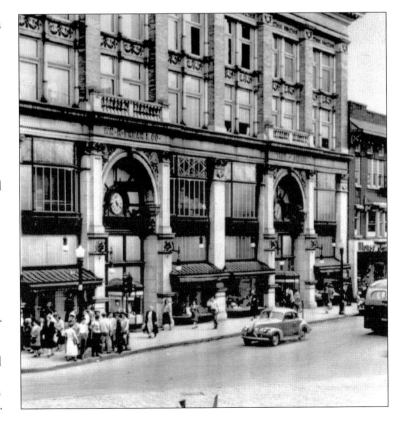

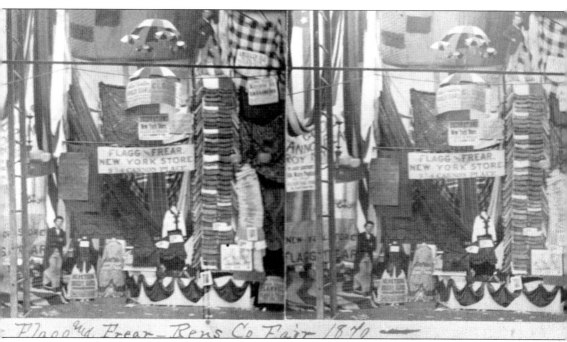

Flagg and Frear – Rens Co Fair 1870

This is a stereo card of Flagg and Frear at the Rensselaer County Fair in 1870. Frear went on his own after this, creating one of the largest department stores in the area. This is probably one of the earliest photographs of the Frear store. Note how high the materials are stacked and the advertised location at the Cannon Building, which Frear purchased later.

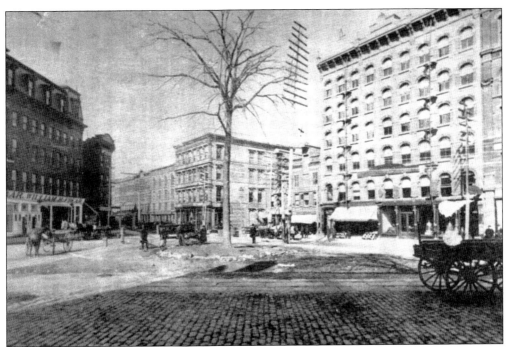

Frear bought the Cannon Building in Washington Square in 1891, creating Frear's Cash Bazaar. The tree has been replaced by the Soldiers and Sailors Monument, and the area is no longer called Washington Square, but is now Monument Square. The building behind the tree was the Warren Hardware Store, a structure completely built of iron.

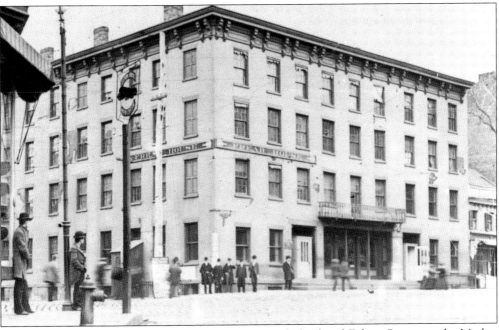

Frear purchased the American Hotel, on the corner of Third and Fulton Streets in the Market Block, and ran it as the Frear House until 1897, when he built the structure seen here, which occupies the site now.

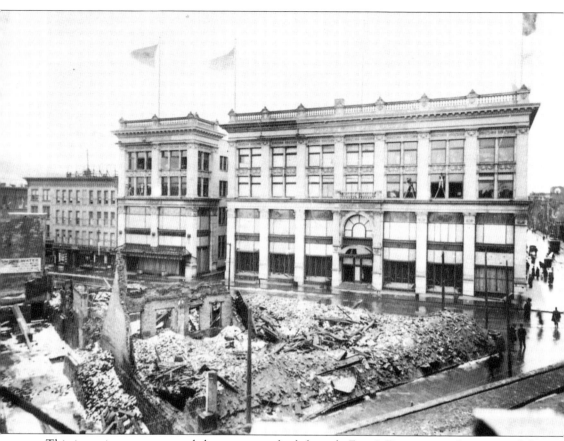

This imposing structure and the annex to the left made Frear's Department Store one of the largest in the Capital District. In the foreground is the debris left from the devastating fire that engulfed the Boardman Building in 1911.

During Christmastime, Santa would present himself on the landing in the atrium for all the little boys and girls to see. It was fun to go onto the landing and look down and see all the shoppers.

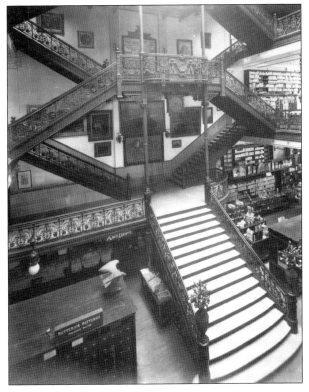

Shown here is the staircase to the first floor. The stairs were later removed and the first floor covered, separating the rest of the atrium, which now houses a drugstore. During the 1950s and 1960s, radio station WPTR operated on the second floor in a glass booth. One could watch Boom Boom Brannigan and Paul Flanagan do their radio shows and take requests.

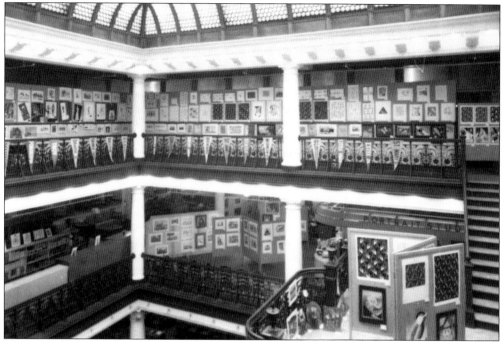

The multi-floored atrium, with its huge sunlight dome, made one feel as though one was in a shopping oasis. While one can still walk up the stairs from the second floor, all of the commercial spaces have been converted to offices.

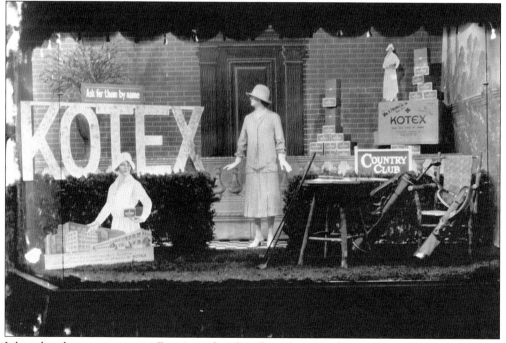

Like other department stores, Frear's used its first-floor show windows to introduce new products. During Christmastime, the many city department stores competed to have the best-looking window displays.

Nine

TROY BUSINESS AND COMMERCE

In 1934, Troy businesses held a fair at which to show off their products. This was a common practice of local businesses, giving the public a chance to see new merchandise. It appears that this fair was held at the Troy Armory. Charles Dauchy Co., located at 279–281 River Street, produced paint and also made church and art glass.

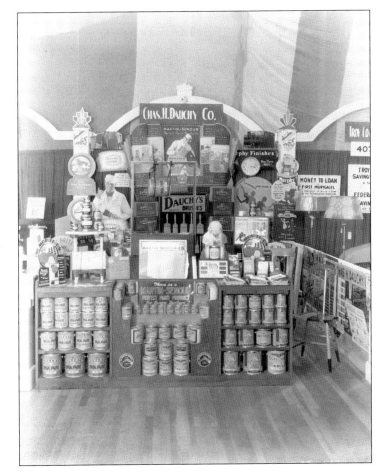

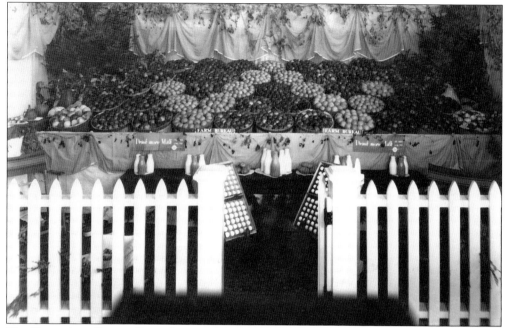

The Rensselaer County Farm Bureau shows off some of the produce made by local farmers. Agriculture is still the primary business in Rensselaer County, and its rolling hills and many farms make the county one of the most beautiful in the state.

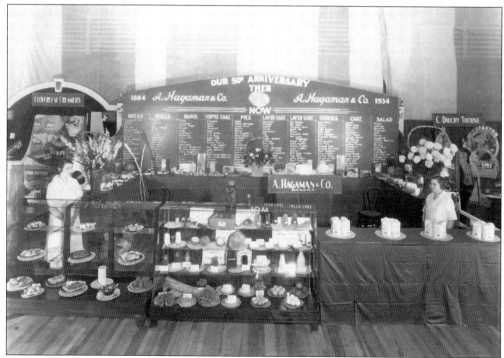

A. Hagaman & Company displays its bakery products and celebrates its 50th anniversary in 1934. The firm was located at 34 Fourth Street. There were many mom-and-pop bakery shops in the city.

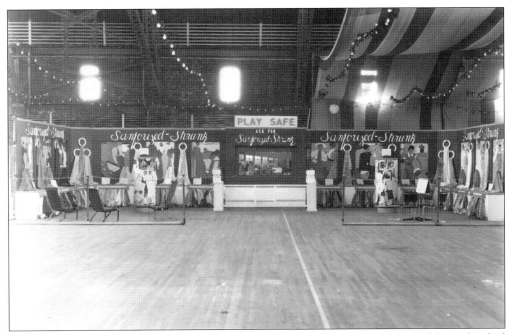

Cluett & Peabody promotes its Sanforized process, which reduced the shrinkage in fabrics. Sanford Cluett (1874–1968) invented the process and licensed it to others. He had 200 patents to his name and could speak the native tongue of the Seminoles.

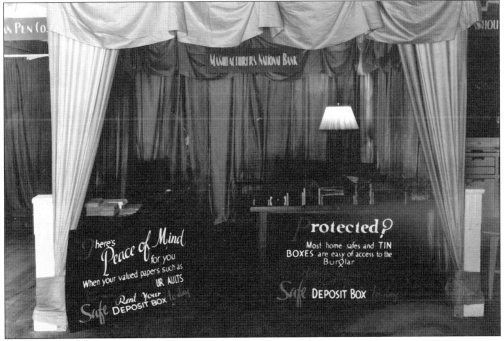

The Manufacturer's Bank offered peace of mind. This bank financed the construction of the USS *Monitor* during the Civil War. The building is now called the Franklin Plaza Ballroom, and it contains the room, brought over from the previous bank building, where the financing of the USS *Monitor* was signed.

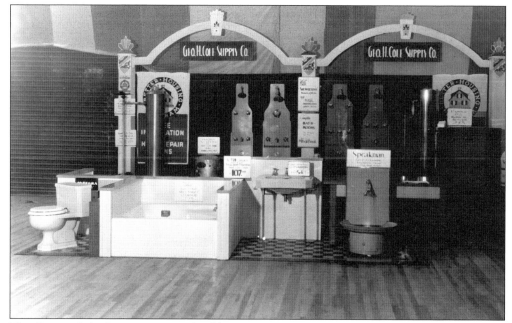

The George Cole Company, at 2405 Fifth Avenue, supplied plumbing and bathroom items. The toilet on the left does not look much different than a modern one. Some technologies, it seems, just work.

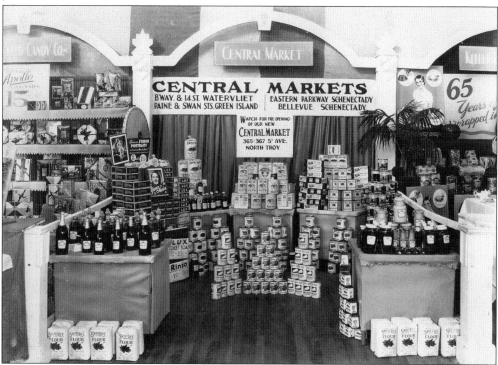

Central Markets, founded by the Golub family in 1922 in Schenectady, is now known as Price Chopper. It is one of the largest food chains in the Capital District. The original store was located in the Burgh and on the corner of First and Jackson Streets.

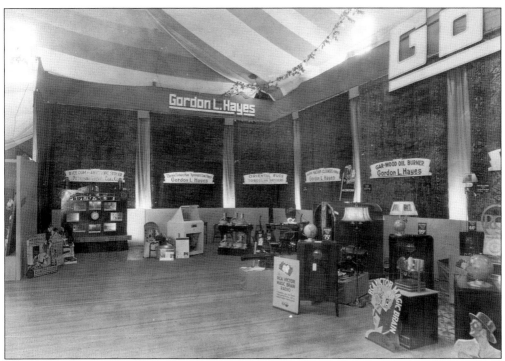

Gordon L. Hayes was a longtime company that sold everything from televisions to heaters for the home. It was located at 401 Fulton Street, on the corner of Fourth Street.

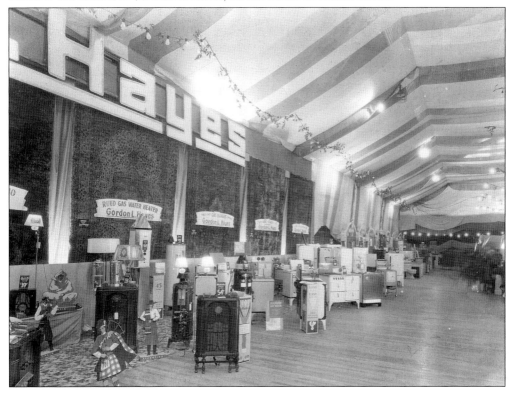

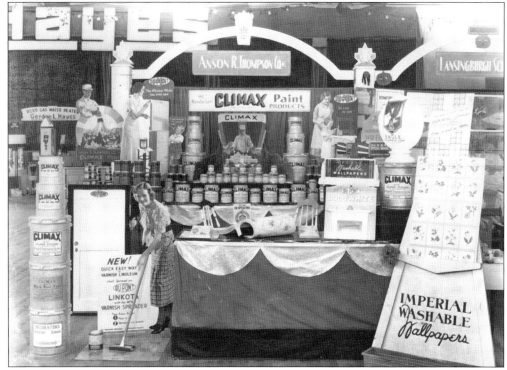

Anson Thompson, a paint specialist, was located at 403 River Street. It incorporated in 1920 to manufacture paints. Thompson, the founder, acquired the Climax Paint Company in 1913. An avid stamp collector, he died on March 17, 1939.

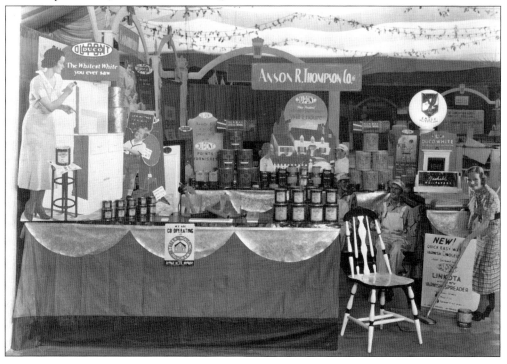

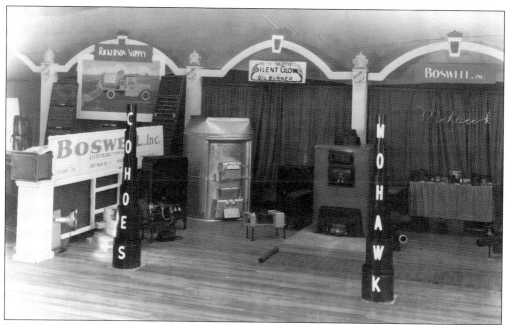

Boswell Distributors was a Cohoes, New York, company. Since it was part of the show, a photograph of the display is included here. The firm supplied all kinds of residential and business heating and furnace equipment.

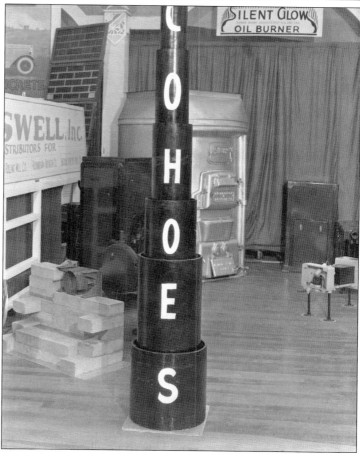

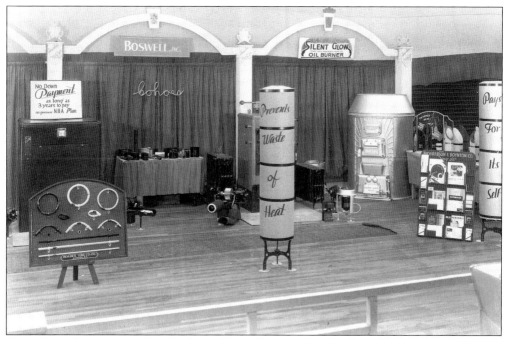

Boswell products are on display here. Boswell was a distributor of other manufacturers' heating products.

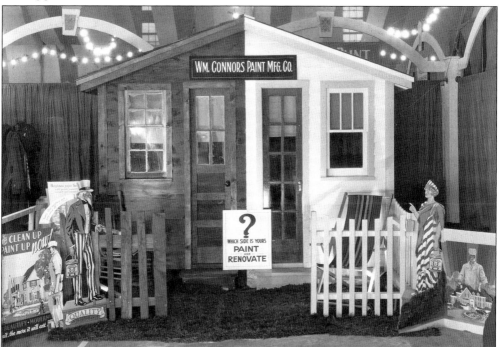

William Connors Paint Manufacturing was located at 669–675 River Street. Established in 1878 on Hill Street, the company manufactured its American Seal paint of white lead and mixed colors. White lead paint was popular at the time, prior to the discovery of its harmful effects on small children.

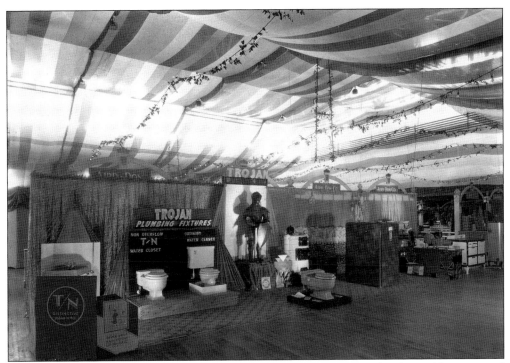

The Trojan Appliance Company, located at 145 River Street, specialized in oil burners and bathroom equipment. The armored-knight logo is a bit anachronistic with the notion of the Trojan War. But then again, ancient Trojans were not using flush toilets.

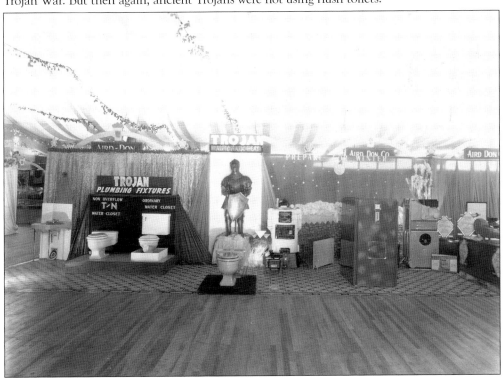

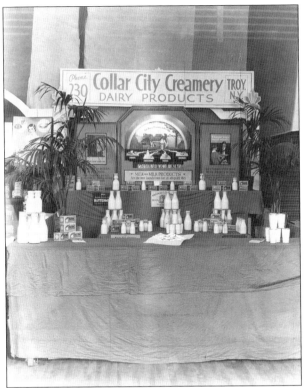

Collar City Creamery was located on Regatta Place in the city's north end. It delivered its products by horse and wagon and later by truck to the customer's door. Its building still stands, but the creamery went out of business years ago, possibly in the late 1950s.

Here, an unknown lighting supplier advertises the economics of using its lighting fixtures. The partial word "rnize" can be made out, but the name of this company could not be determined.

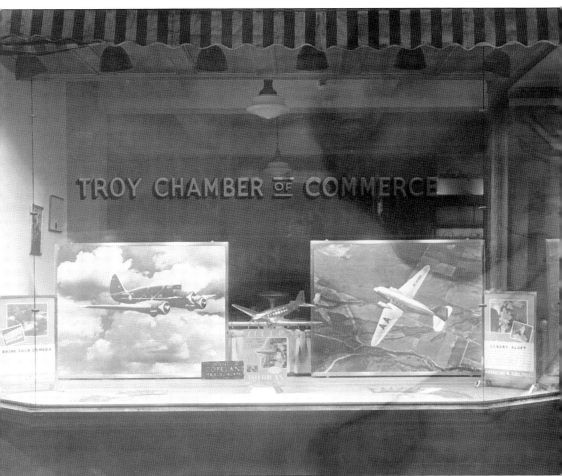

The Troy Chamber of Commerce, at 453 Broadway, advertises, on the right, an American Airlines DC-3, identification number NC14988, which was built in 1936 and was the first DC-3 put into commercial aviation service. The chamber was very aggressive in promoting the city's local businesses. It held an annual Troy Week and various expositions to show off local products and promote the history of the city.

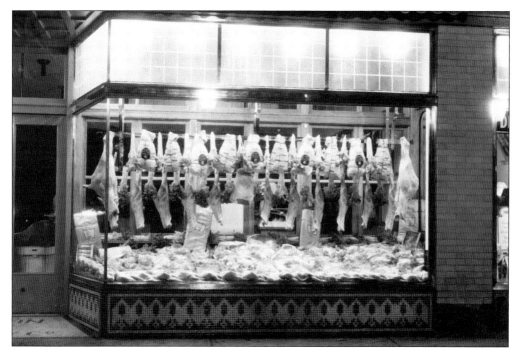

The Boston Meat & Grocery Company was located at 538 Pawling Avenue. It also had stores at 330 Second Avenue, 611 Second Street, and 840 Fourth Avenue in the Burgh, equipped with GE Novalux Floodlight Luminaries, Form 27 with 118, and 1118 glassware. This photograph was taken on October 24, 1932. (Both, courtesy of Chris Hunter, archivist, Museum of Innovation and Science, Schenectady.)

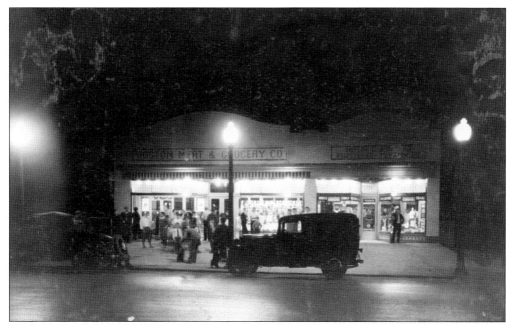

Here is a night view of the Boston Meat Store at 538 Pawling Avenue in the city's Albia section. The building is still being used by a local business, but the GE light poles are no longer there. This photograph was taken on October 24, 1932. (Courtesy of Chris Hunter, archivist, Museum of Innovation and Science, Schenectady.)

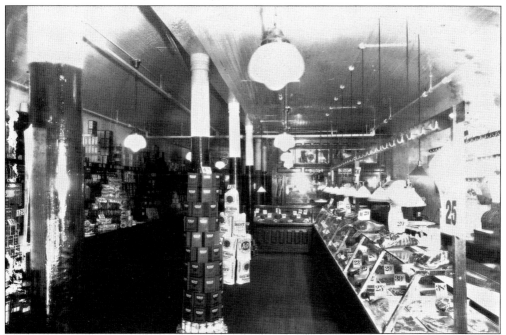

This is the interior of the A&P store at 357 River Street. When the author was a teenager, the A&P was located in the Chazin Building on Fourth Street. From 1920 to the 1960s, A&P was the largest retailer in the world, and at one time had almost 16,000 stores. The author's mother would grind up fresh A&P coffee beans.

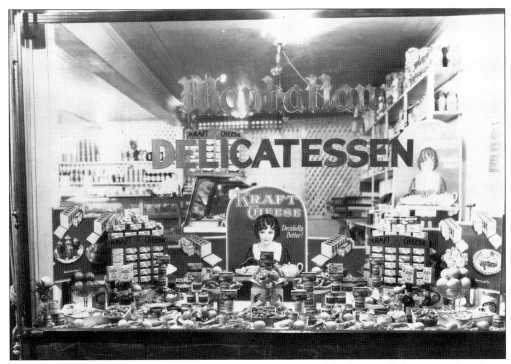

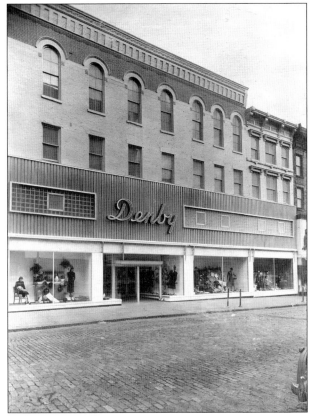

Manhattan Deli, at 157 Fourth Street, is seen here in 1935. There were many delis in Troy. One of the author's favorites was Lou's Deli on River Street near the Taylor Apartments. One could sit down and get a great sandwich and select a cold pickle from the pickle barrel that stood near the counter.

Denby's was located on the northwest corner of Fulton and River Streets. One of the more popular local department stores, this is where boys would purchase "Old English" (English Leather) and Canoe cologne to impress the girls. The building was destroyed, along with the other businesses on the block, during urban renewal in the 1970s.

The Enna Jettick Boot Shop was located at 42 Third Street. It is seen here in 1935. A shoe width of AAAAA sounds very narrow. The building now houses a pawnshop.

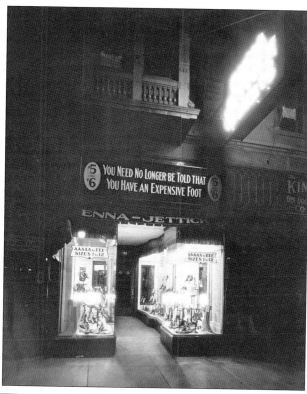

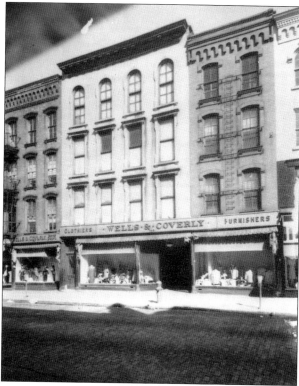

Wells & Coverly, another popular clothing store, was located at 334–340 River Street. Unfortunately, this part of River Street was removed during the urban renewal misadventures of the 1970s. The entire block of buildings is gone.

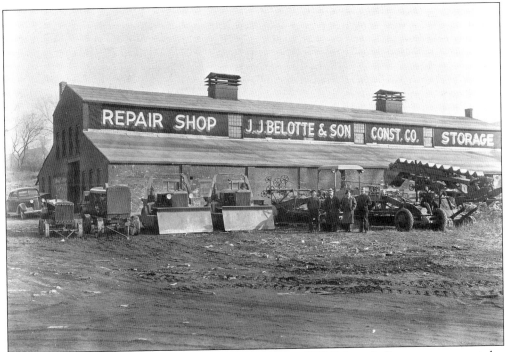

This is the J.J. Belotte & Son repair shop and storage, at 2705 Fifteenth Street near present-day Frear Park. The area is now a residential neighborhood.

Edwin E. Darling, Food Wholesalers, was located at the end of Fulton Street, on Front Street on the river. It is seen here in the 1930s. The building at the far right is Denby's Department Store. All of these buildings were demolished in the 1970s.

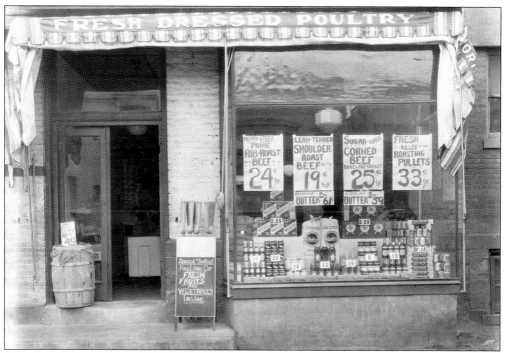

The IGA (Independent Grocers Alliance) store bartered with local farmers for fresh produce. Several local grocers, such as this one at an unknown location, belonged to the IGA network. Prime rib was going for 24¢ a pound. Those days may never come back.

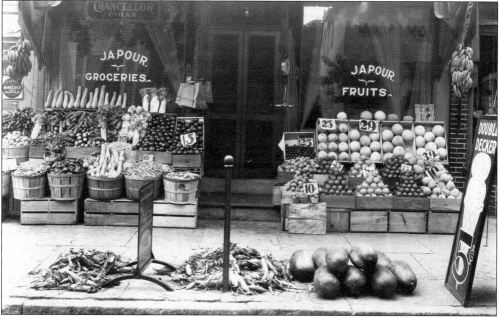

Michael Japour had his grocery store at 441 Fifth Avenue in the Burgh. There were small mom-and-pop stores in every neighborhood in Troy. A customer could open a tab at a local shop, charging groceries and wait until payday to go in and pay the tab. Note the sign for the double-decker ice cream cone for 5¢.

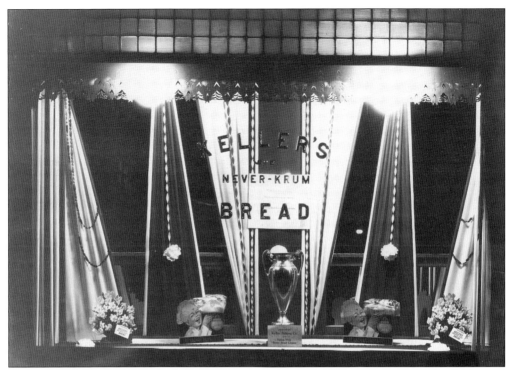

For years, Trojans could get fresh bread from Keller's Baking Company, at 3000 Sixth Avenue and at 43 Ingalls Avenue in Troy. Julius Keller was the company's president, and Gustav Keller was the vice president. The bakery was famous for its Never-Krum bread.

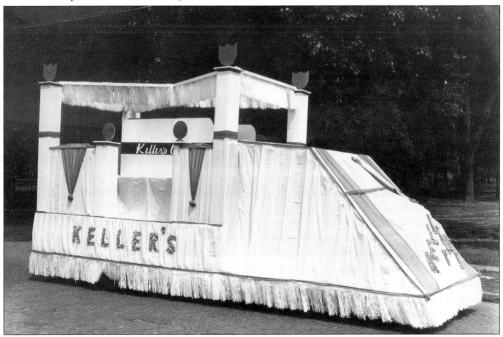

The Keller's Bakery float was used in local parades. The float looks pretty plain here, but it probably carried lots of bakery products when in parades. Trojans loved their parades.

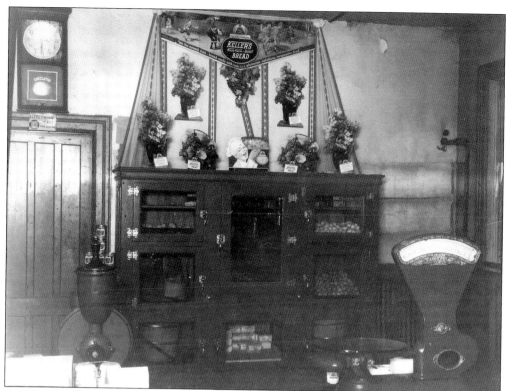

A Keller's Bakery bread display is seen here on top of an egg cabinet in an unidentified Troy store. The company's slogan was "For the normal child, bread made with milk is a wholesome, nutritious, inexpensive food."

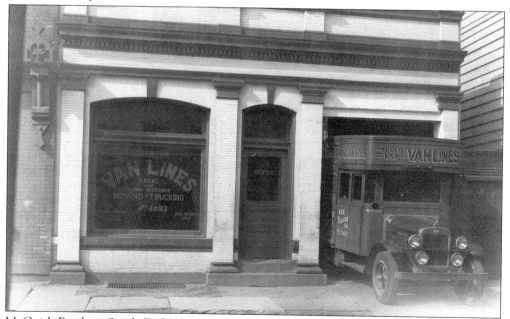

McGuirk Brothers South End Van Lines, "The Home of Careful Movers," had its office and warehouse at 347–374 Second Street. It is seen here in the 1930s.

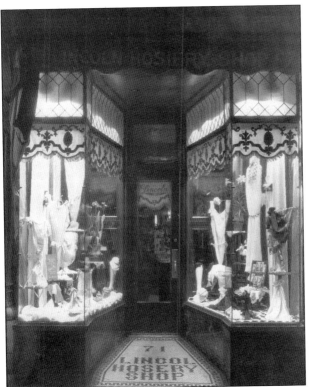

During the 1920s, the Lincoln Hosiery Shop was located at 71 Third Street, next to the Lincoln Theater. Note the tiled nameplate on the entrance floor. Someone did not plan ahead, it seems. The name Lincoln has run out of space, and "hosery" is misspelled. This building no longer exists.

Get your fruits and vegetables! The Mohican Market, located at 363 River Street, is seen here in 1935. Sunkist oranges were 33¢ a dozen.

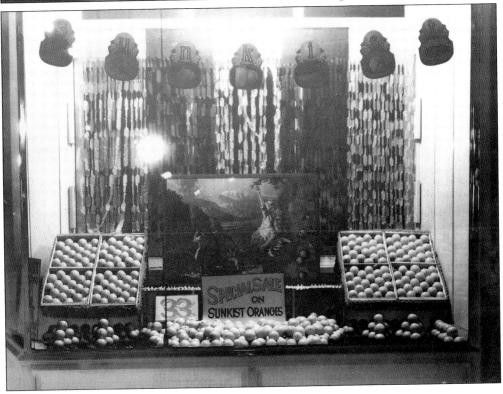

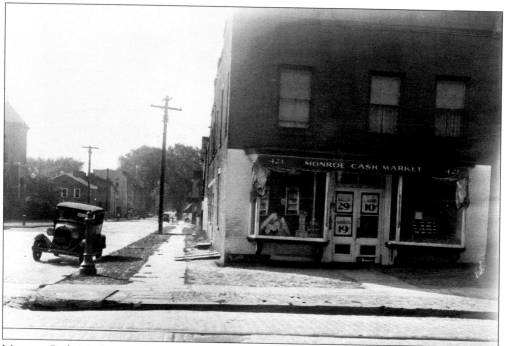

Monroe Cash Market was located at 421 Fourth Street, at Monroe Street, and was owned by Henry J. Murray. It is seen here in 1935. This building is now a residence. Almost every corner in Troy had a mom-and-pop store in the days before large supermarket chains.

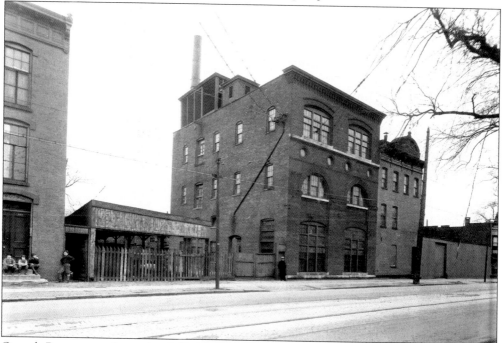

Quandt Brewery was located at 867–869 River Street. Adam and Andrew Quandt hailed from Troy, New York. The family had come from Germany in the 1850s. This company went bankrupt in 1941.

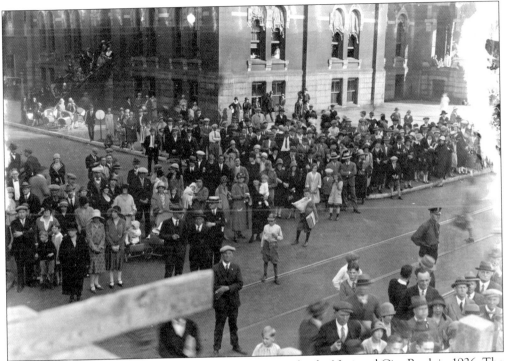

These photographs depict the laying of the cornerstone for the National City Bank in 1926. The bank merged with National City Bank of Cohoes in 1948, then with the State Bank of Albany in 1959. Its name was changed to State Norstar Bank in 1988, and finally to Fleet Bank in 1992. (Both, courtesy of Tom Clement.)

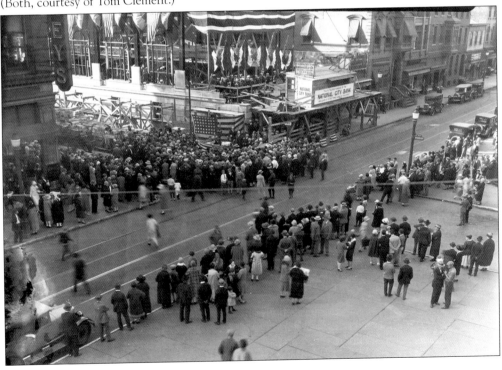

Here is another view of the crowd at the groundbreaking ceremony for National City Bank in 1926. Note the women's cloche hats. Across the street is Stanley's Department Store, which is now a high-end condominium. (Courtesy of Tom Clement.)

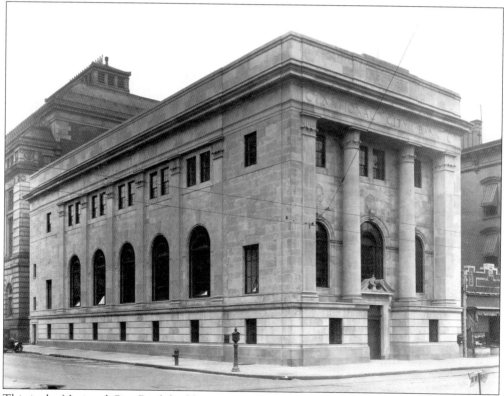

This is the National City Bank building as it appeared in 1960. This location was once the site of the Arba Read Fire House. It was not uncommon for the uses of city corners to change over time. The small building on the right was the Vanity Fair Shop. It is now the site of an ATM for the current institution, Bank of America.

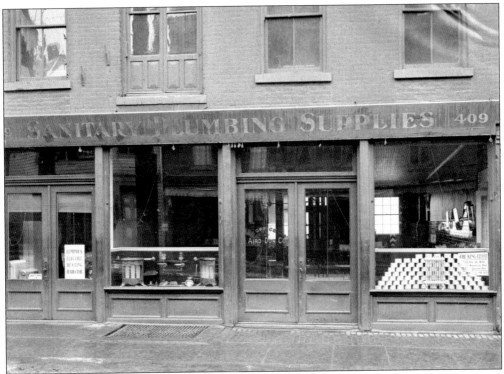

Plumbing supplies are on display at the Aird-Don Building, at 409–415 River Street. This window display, and those seen in the next five photographs, show off General Electric's luminous radiators, a big hit in 1912, along with bathroom fixtures. (Both, courtesy of Chris Hunter, archivist, Museum of Innovation and Science, Schenectady.)

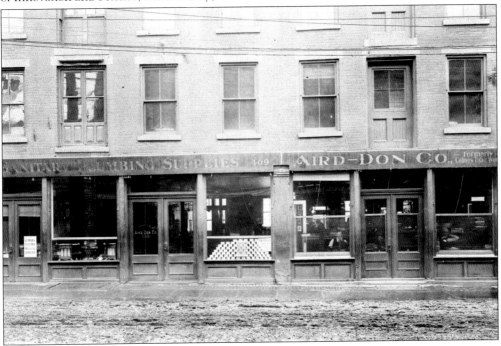

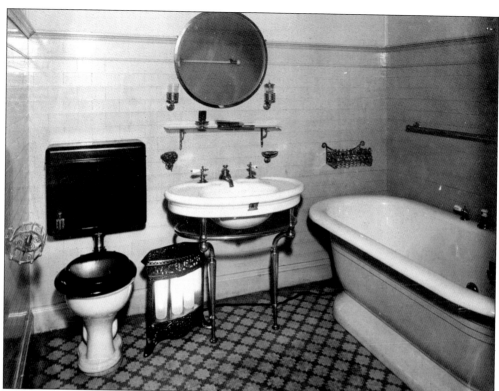

Shown here are two versions of "Bathroom Setup No. 1" at the Aird-Don Building. The General Electric (GE) heater is featured in both displays. (Both, courtesy of Chris Hunter, archivist, Museum of Innovation and Science, Schenectady.)

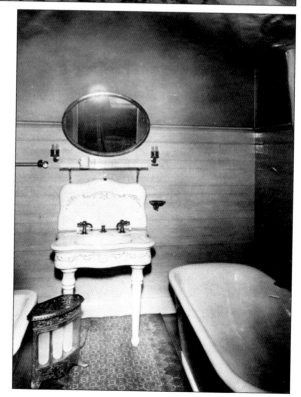

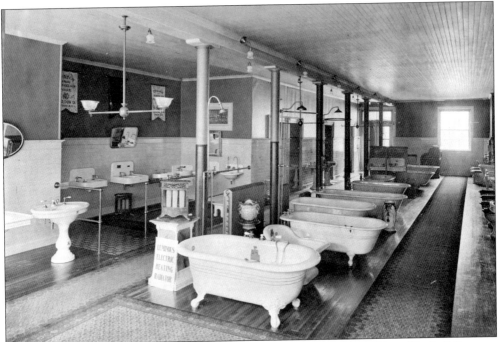

Here is another bathroom showroom, including sinks, at the Aird-Don Building. The building now houses offices, a church, and a retail shop. This part of town is the former collar and cuff section of the city. (Courtesy of Chris Hunter, archivist, Museum of Innovation and Science, Schenectady.)

An early Troy shoe shop is seen here. The business's location is unknown. Many shoe shops were found along the major downtown streets—River, Third, Fulton, and Fourth. The author can remember at least four on one block.

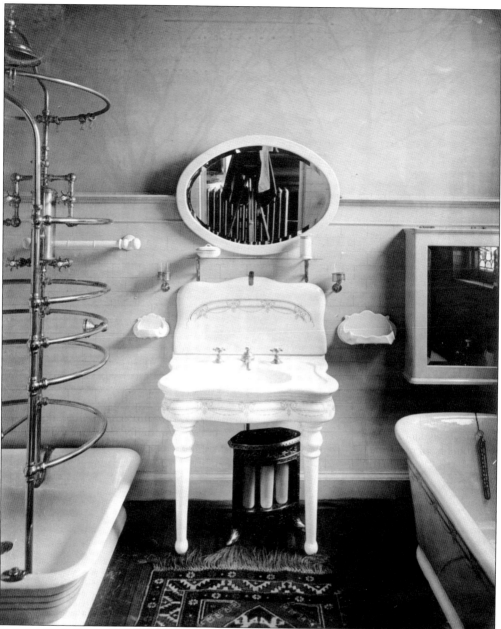

"Model Bath Room No. 3" includes a GE heater under the sink. This display was in the Aird-Don Building. (Courtesy of Chris Hunter, archivist, Museum of Innovation and Science, Schenectady.)

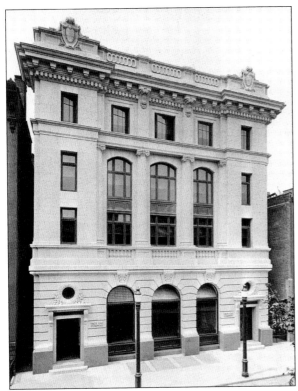

The Troy Gas Light headquarters on Second Street, seen here, is now the Pioneer Savings Bank. The light company owned the gasholder building, which is still standing in south Troy, and supplied gas throughout the city. In 1926, it merged with the Mohawk Hudson Power Company.

A window display in the Troy Chamber of Commerce Building celebrates "Let's Know Troy Week," January 24–27, 1928. Featured Troy businesses included Meneely Bells, Hudson Valley Coke Company, Freihofer's, and more.

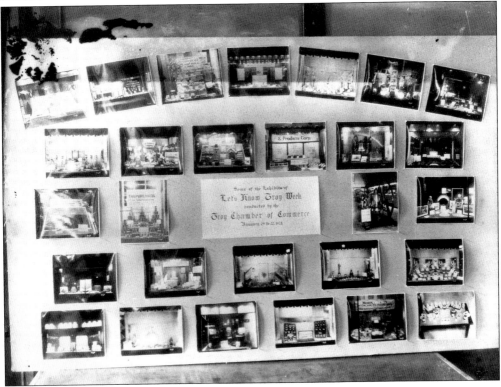

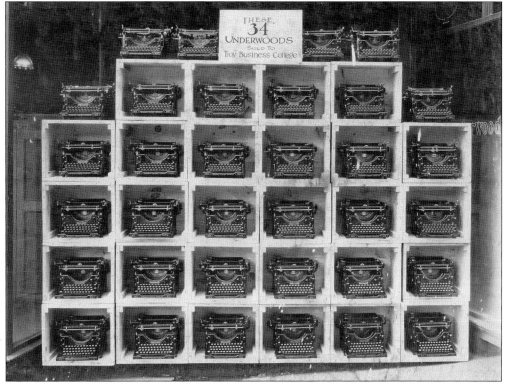

These 34 Underwood typewriters were sold to Troy Business College (now Bryant & Stratton) at 11 First Street. Underwood was at 297 River Street in 1935. These typewriters were the latest technology at the time. Most fourth-graders today have never heard of typewriters.

Shown here is the opening of Union National Bank, at 56 Fourth Street. It was established in 1851 and went out of business in 1974. These high-vaulted ceilings were not practical from a heating point of view, but must have conveyed a sense of wealth and posterity to the bank members.

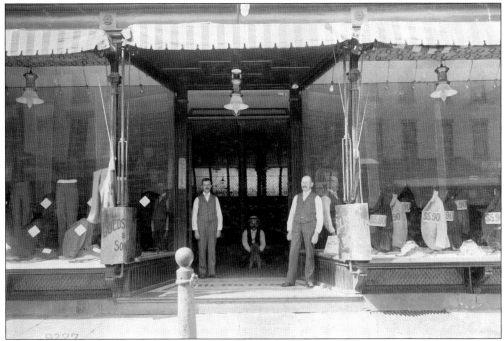

Seen here is the Goldstone & Sons Clothing Store in 1898. The firm, located at 105 Congress Street, later became Goldstone Bros. Benjamin and James were the siblings of the name. (Both, courtesy of Chris Hunter, archivist, Museum of Innovation and Science, Schenectady.)

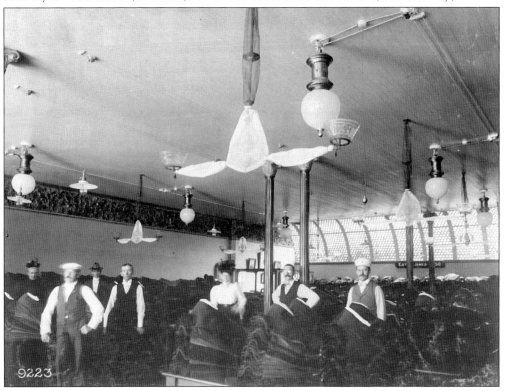

In the 1940s, this building became the home of Central Markets, on the corner of First and Jackson Streets. The company is now known as Price Chopper. Behind the building is the Castle, or Fortress, a waste recycler.

Shown here is the cutting room, featuring GE DC multiple-arc lamps, at Cluett & Peabody Collars and Cuffs on River Street. This structure is now the Hedley Building. (Both, courtesy of Chris Hunter, archivist, Museum of Innovation and Science, Schenectady.)

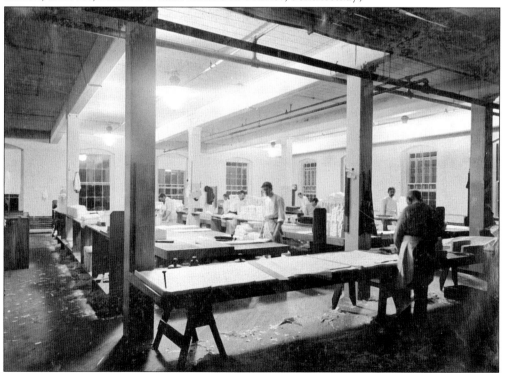

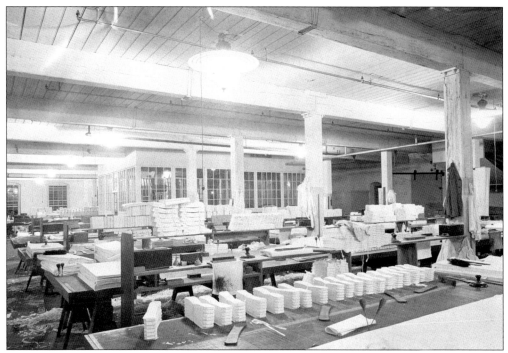

Pictured here is another view of Cluett & Peabody's cutting room in 1903. (Courtesy of Chris Hunter, archivist, Museum of Innovation and Science, Schenectady.)

The cutting room is seen here on March 15, 1917. The room is lit with GE Mazda lighting. General Electric was testing its new DC multiple-arc lamps at the time. Before the incorporation of electric lights, work was done under gaslight.

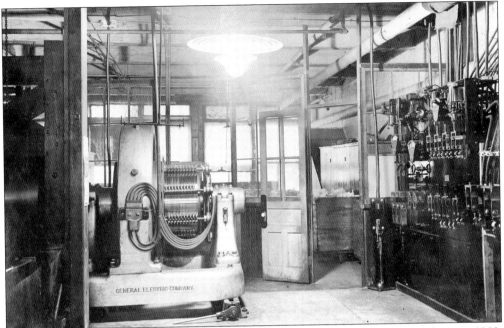

This is Cluett & Peabody's GE-illuminated engine room on River Street, seen here in 1903. The building is today used by commercial and government offices, including city hall, which recently moved into the building. (Courtesy of Chris Hunter, archivist, Museum of Innovation and Science, Schenectady.)

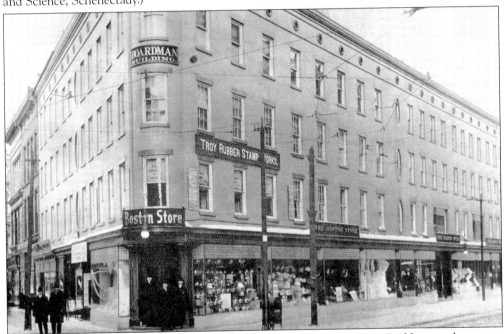

When the Boston Store moved into Troy, it settled first in the Boardman Building, at the corner of Fulton and River Streets. The building burned down in 1911. The previous version of the Boardman Building housed the Peale Museum, where the stage version of *Uncle Tom's Cabin* was first performed in America.

Ten

STREET SCENES

Monument Square, originally known as Washington Square, is seen here, with the Cannon Building in the back. The cornerstone for the Soldiers and Sailors Monument was laid on May 30, 1890. The Cannon Building, designed by the famed architects Alexander Jackson Davis and Ithiel Town, was built in 1835.

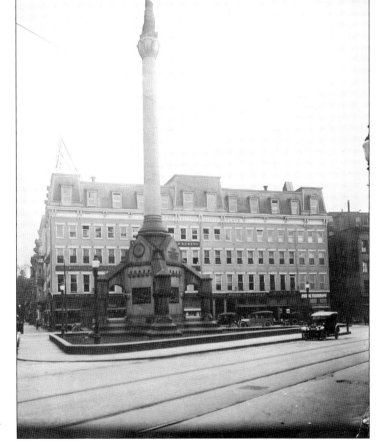

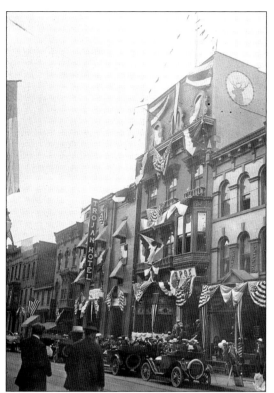

The BPOE (Benevolent and Protective Order of Elks) Lodge and the Trojan Hotel are fitted with decorations. Perhaps an event of special significance is under way. There were several fraternal organizations throughout the city during this period. The lodge building and the structure at far right no longer exist. The Trojan Hotel, now closed, was a flophouse in the 1970s.

The Niagara & Hudson Coke Company in south Troy is seen here on November 13, 1951. These buildings were formerly associated with the Burden Iron Company. Everything in this photograph is gone. Burden Iron was famous for making most of the horseshoes for the Union army during the Civil War. Henry Burden's sons did a poor job of keeping the company afloat following his death. South Troy used to glow at night from the industry's activity, but it now sits quiet.

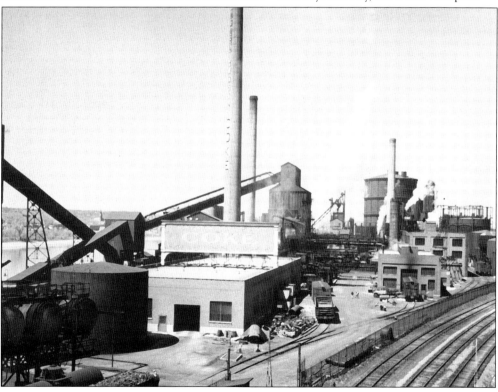

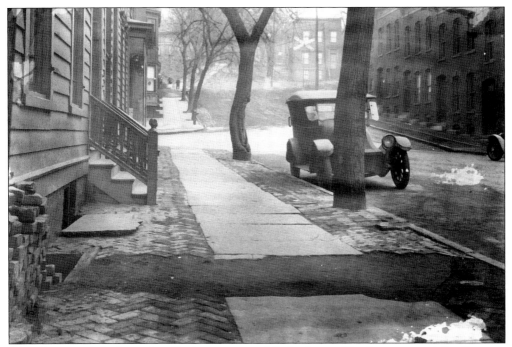

This photograph looks up Ingalls Avenue toward Eight Street. The beginning of Orr Street is also visible in the center of the photograph. Most of the buildings on lower Ingalls have been razed, but the cluster seen here still remains.

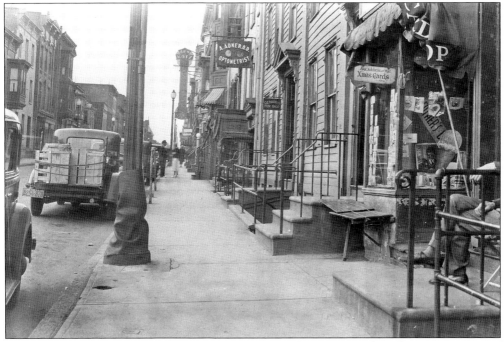

Here is a view of a busy Fifth Avenue just north of Columbus Square and Jacob Street. Sections of cities ebb and flow; this stretch of Fifth Avenue today is rundown, with several missing buildings and very little commercial activity.

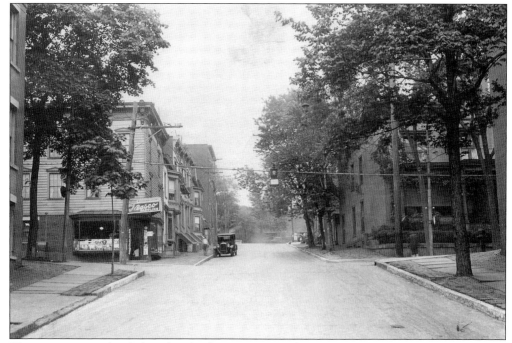

The intersection of Eighth and Federal Streets is seen here in the 1920s. At 803 Federal Street was the grocery store of Michael Quillinan (at left). In the 1960s, the building housed a head shop called Incandescent Apricot.

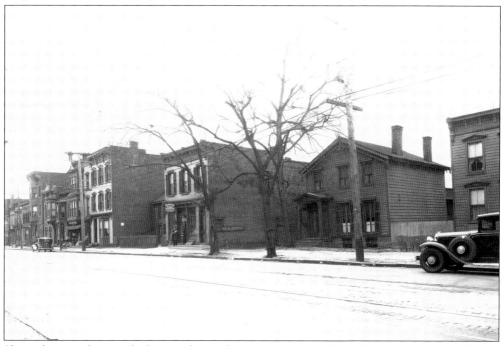

Shown here, in this view looking to the southwest, is a stretch of River Street. At center is Charles Loeble & Sons Roofers, at 857 River Street near Glen Avenue. The building and four others to the left have been razed, but others survive.

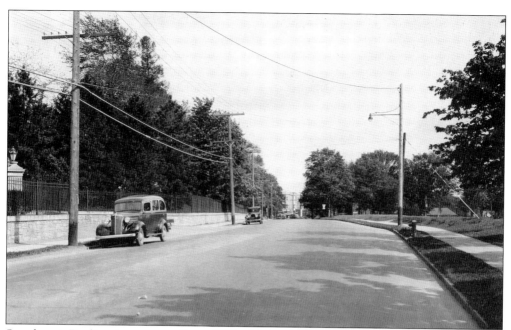

Seen here is Pawling Avenue near Emma Willard School on May 24, 1937. The streetlights are new GE Novalux Luminaries, Form 72R. (Courtesy of Chris Hunter, archivist, Museum of Innovation and Science, Schenectady.)

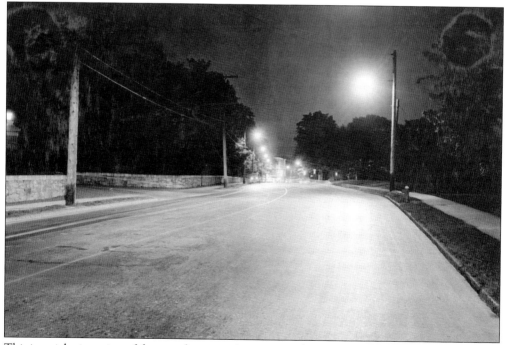

This is a nighttime view of the stretch seen in the previous photograph, Pawling Avenue near Emma Willard School, on May 24, 1937. Supplying illumination are new GE Novalux Luminaries, Form 72R. (Courtesy of Chris Hunter, archivist, Museum of Innovation and Science, Schenectady.)

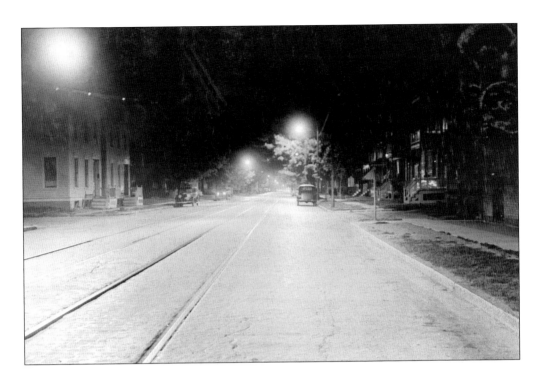

Above, Second Avenue is seen on the night of September 10, 1937, with GE Novalux Luminaries Form 72R lighting the scene. The same lighting appears in the photograph of Fifth Avenue below. (Both, courtesy of Chris Hunter, archivist, Museum of Innovation and Science, Schenectady.)

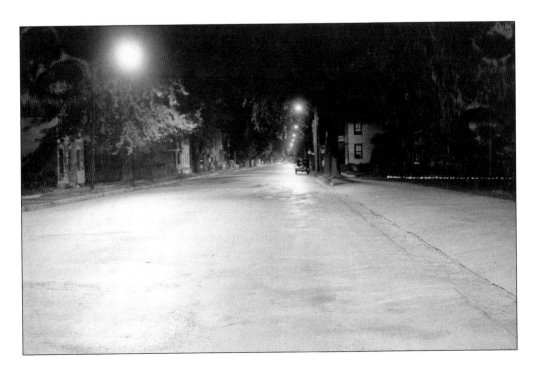

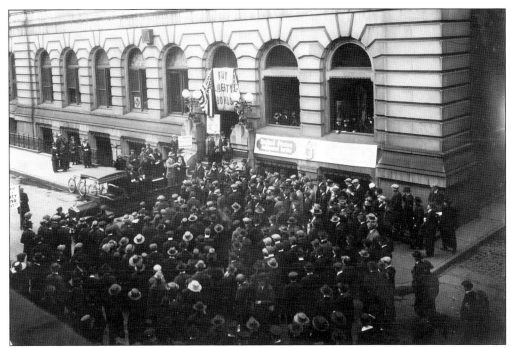

During the First World War, citizens gather to buy Liberty bonds at the Troy Savings Bank, at the corner of State and Second Streets. In this building is the Troy Music Hall, which has some of the best acoustics in the world. The bank is no longer in use, and the fate of the building remains unclear.

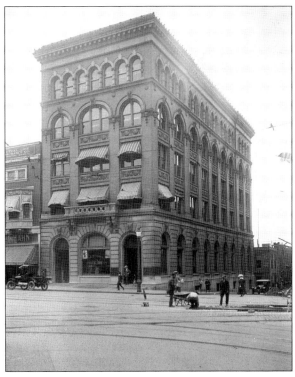

The National State Bank was built in 1904. In this c. 1912 photograph, workers are laying Belgian blocks around the trolley tracks. Finch & Hahn, in the building on the left, sold Graphophones at this 295 River Street location. Graphophone was a trademarked name for the phonograph invented by Alexander Graham Bell and sold by Bell's Volta Graphophone Company beginning in 1885. The American Graphophone Company (Bell & Trainer in 1886), the North American Phonograph Company (Jesse Lippincott in 1888), and Columbia Phonograph Company in 1899 (later known as Columbia Records) all either produced or sold the device.

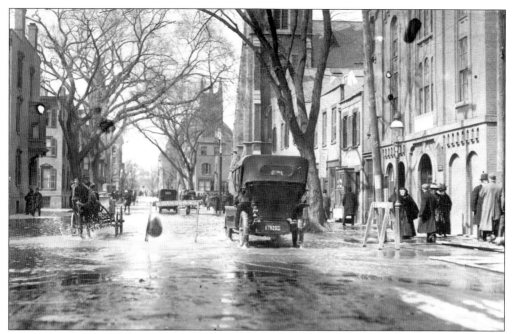

A water main break has occurred near the alley between Fifth and Sixth Avenues on State Street. St. Paul's Episcopal Church, with its square steeple, can be seen in the background. The church on the right is the First German Church, erected in 1863.

This photograph, taken sometime after 1923, shows the same location seen in the photograph above, between Fifth and Sixth Avenues on State Street. The new fire station is on the right. The First German Church, seen on the other side of the alley, has been razed, along with the buildings adjacent to it.

Seen here is Troy City Hall, at the corner of Third and State Streets. After the building burned down in the 1930s, the lot sat vacant. It was later turned into Barker Park. The village burial ground occupied this site before city hall was built. The graves, at least most of them, were removed to Oakwood Cemetery.

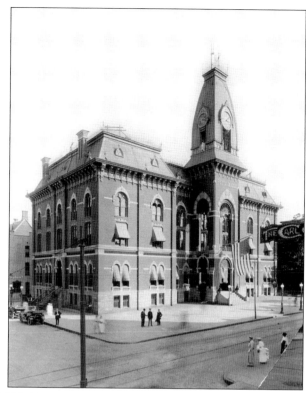

This view is looking down Congress Street from Seventh Avenue. Just past the parked car is the Congress Street train tunnel. The author found a chemistry laboratory in one of the buildings on this street after they were abandoned. One of the buildings was Tom's Bar, which had a separate women's entrance. The author's father bought him Polish sausage (kielbasa) there.

This street-level view looks to the north side of Congress Street from First to River Streets. The block across the street was known as the Wotkyns Block and contained several apartments and retail establishments, such as Al's Deli, Five L's Grill (no. 17), Charlie Chu Laundry (no. 29), and Chesman's Used Furniture Store. Patricelli Restaurant (no. 15), known to serve great pizza, was on the alley corner. Bridge Diner (also called Gus's Silver Diner) was at the corner of River Street.

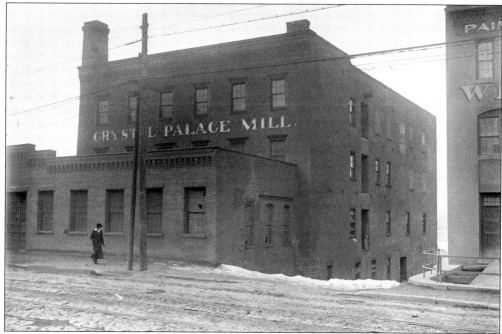

One of the earliest manufacturing locations in Troy was near Middleburgh and River Streets. The Crystal Palace Mill building was part of an earlier flour mill complex. Alongside it were the Connors Paint Company and the Orr Paper Mill complex. A canal ran in front of the buildings to supply waterpower to all of the mills.

The view in this photograph looks down Grand Street from Seventh Avenue to the railroad tracks. Many beautiful row houses were built in Troy during the 19th century. This neighborhood was obliterated for the most part during urban renewal but replaced with nothing.

This view is looking east on Fulton Street from Fourth Street. The Ilium Building and the old Troy Times Building are on the right. Note the trolley tracks. The Ilium Building was designed by well-known Troy architect Marcus Cummings. Part of the Union Railroad depot can be seen past the Calhoun Electrical Supply building. The Troy Hospital is at the top of the hill.

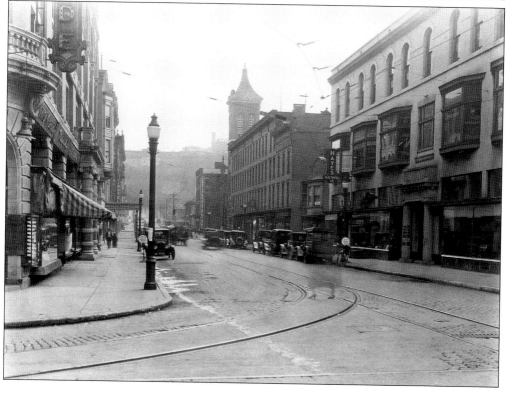

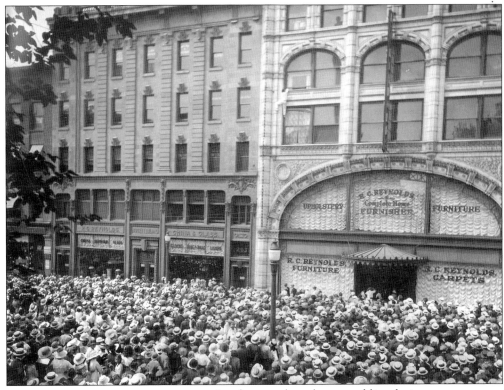

In what may have been a public relations stunt, a man dressed in white is climbing the McCarthy Building, which at the time served as the R.C. Reynolds Furniture Store. A large crowd has gathered to watch. Both of the buildings seen here were slated for demolition during urban renewal, but the city ran out of money.

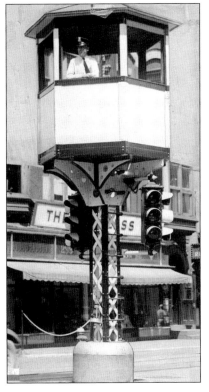

This traffic tower was erected at the intersection of Fulton, Third, and River Streets. In all likelihood, it did not last very long. This was one of the busier commercial corners in the city. The building in the background, at 298 River Street, was on the northwest corner of Fulton and River Streets and was known as the Cronin Building.

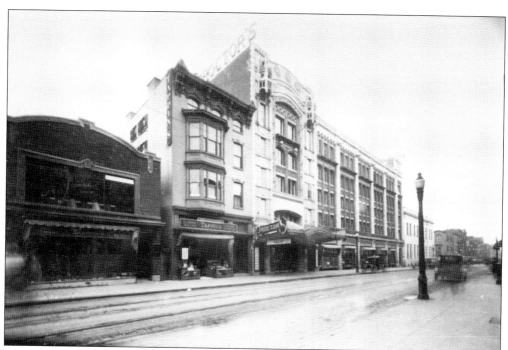

This view of Fourth Street shows Proctor's Theater, which opened in 1913. To the left is Tappin's Jewelry, an old Troy establishment from the 19th century. Proctor's, originally a vaudeville house, was later converted to a movie house. There is a movement to restore the building.

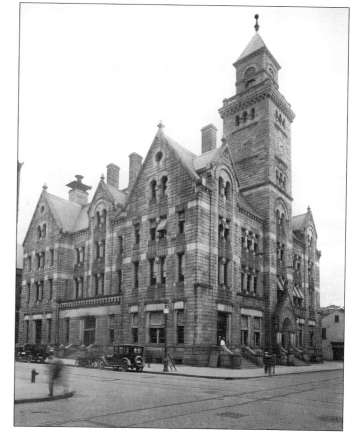

Shown here is the former post office, located where the current one is, on Broadway and Fourth Street. This structure was built in 1894 and replaced in 1936 with the current one. The latter's construction was undertaken as a WPA project. The building on the far right was a men's hotel and is now Finnibar's Irish Pub.

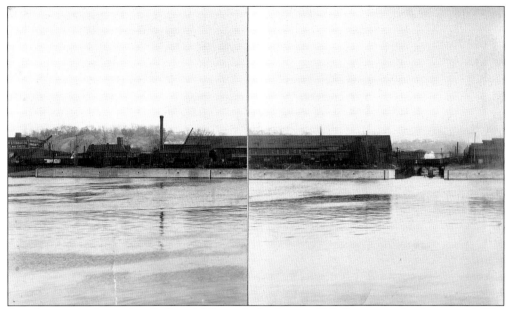

Seen here is the Rensselaer Rolling Mills, with the Poesten Kill flowing in the foreground. The complex was later used by Ludlow Valve, but it burned down in the late 1960s. The mills made parts for the USS *Monitor* during the Civil War. As Ludlow Valve, it built some of the largest valves in the world.

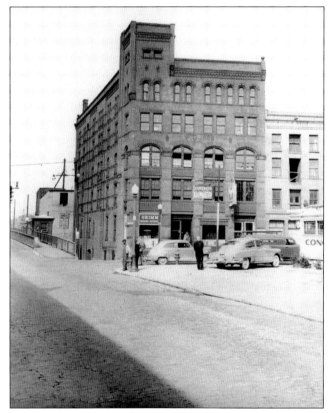

In this photograph, Congress Diner is on the right and Thompson's Drug Wholesale is on the corner. The old Congress Street Bridge is just visible on the left. Out of the frame of this photograph to the left were built the Taylor Apartments for returning Korean War veterans in the early 1950s.

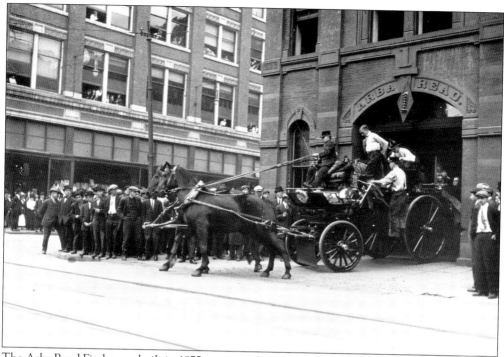

The Arba Read Firehouse, built in 1875, was torn down to make room for the National City Bank. In 1860, the first steam engine was delivered, and the Arba Read Steam Fire Engine Company No. 1 was established.

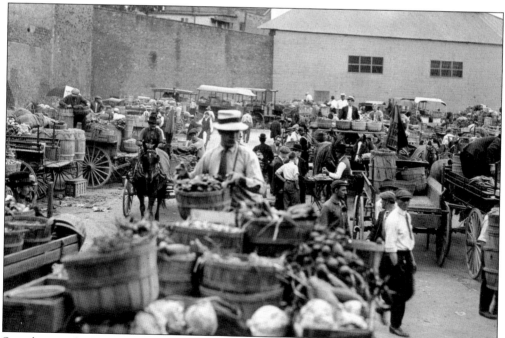

Seen here is the Farmers Market on the old gasholder site between Fifth Avenue and Fourth Street in Little Italy. A public market was located in this area of Liberty Square since the early part of the 19th century.

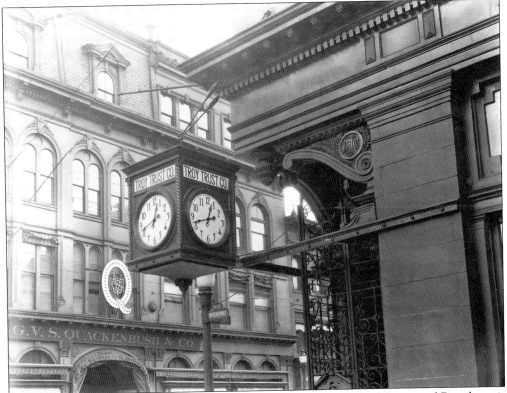

The clock of the Troy Trust Company, on the southwest corner of Third Street and Broadway, is seen in this photograph. The Quackenbush Department Store is across the street.

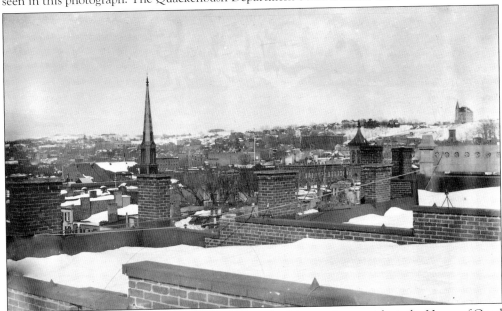

This rooftop view of Troy faces northeast. The large building at the top right is the House of Good Shepherd, on the south side of People's Avenue and Fourteenth Street and east of Ninth Street. The institution catered to "fallen women desiring to lead a pure life." It was built in 1886.

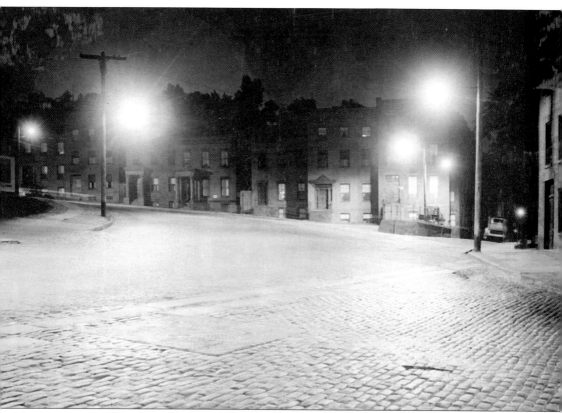

The intersection of Congress Street and Seventh Avenue is pictured on May 24, 1937. The scene is illuminated by GE Novalux Luminaries Form 72R. The author lived in one of the houses, third or fourth up, in the 1960s, and the author's cousin lived in the first building on the right with the car parked in the front. (Courtesy of Chris Hunter, archivist, Museum of Innovation and Science, Schenectady.)